AFTER

The Obligation of Beauty

Mindy Weisel

For Jackee —
With all loving
wishes — Jerusalem
2021

OTHER BOOKS BY MINDY WEISEL

Daughters of Absence: Transforming a Legacy of Loss

Touching Quiet: Reflections in Solitude

The Rainbow Diet

ILLUSTRATION

The Beginning of Things
Text by Harry Rand/Paintings by Mindy Weisel

Women's Voices From the House of Time
Edited by Martina Kohl

Women's Voices II
Edited by Martina Kohl

For

Asher, Sammy, Lily, Lee, Ely, and Nili

My *After*

In Loving Memory of Ronald David Weisel

The art of Mindy Weisel has a profound power. She invites her audience to peer into the darkest depths of the Holocaust, yet continuously finds light. Her use of colour speaks of a world filled with deep sorrow, yet the search for beauty survives. The Holocaust takes material form, engulfing the other colours which "drip as if they were tears," as Mindy Weisel recalls. Her work holds the viewer utterly transfixed. Still, at their core, her paintings offer a second-generation perspective: a vicarious remembrance, and a profound sense of hope which reaches out to the generations to come.

– Ambassador Andreas Michaelis, German Ambassador to the United Kingdom

In the world, as we know it today, one must create beauty and this Mindy Weisel has done again and again, in her art, her writing, her teaching and her being. Her work is a compelling response to the Shoah, a way to live After. We are the visual and spiritual beneficiaries of Mindy's Obligation of Beauty. In this meaningful volume we catch a glimpse of the beauty she has created as she shares with her readers why this is the path she has chosen. A path which believes in life.

– Michael Berenbaum, Director, Sigi Ziering Holocaust Institute, American Jewish University

Mindy Weisel's work is miraculous, combining art, poetry, memoir, and soul. One of the finest contemporary painters living today, Weisel creates dynamic, multi-genre worlds of shape and emotion. Sure-handed, freeing, this work speaks with the angels while confronting the demonic in history. The poetry is eloquent and spare, coming to us from a meditative space that uses silence as canvas, reveres language as rescue. The memoir gives this manuscript its roots and gravitas, resonating with family trauma. Mindy Weisel's parents were Auschwitz survivors. The artist grapples with what that history means to her as a daughter and a person living in a contemporary world. This work educates and lifts us. Mindy Weisel's *After* helps us to feel more human in these perilous times. We cannot deny history, but art such as Weisel's permits us to confront, articulate and embrace what has happened to us, helps us to shape who we want to be.

– Marilyn Kallet is the author of seven books of poetry, including *How Our Bodies Learned*, 2018

AFTER is read in one stride… Mindy Weisel has found a convincing way, for herself and for us, to live a life in the face of evil. With parents who survived the evil of Nazi Germany, she speaks of beauty and love. … AFTER is powerful. May it serve as a guidebook for humanity, as a humanistic creed to never again experience another "Before."

– Ambassador Ulrich Sante, German Ambassador to Argentina

"Who can return the violated honor of the self? I cannot claim
that art is all powerful magic, or pure faith, but one virtue
cannot be denied it: its loyalty to the individual, its devotion to
his suffering and fears, and the bit of light which occasionally
sparkles within him…"

– Aharon Appelfeld, *Beyond Despair*

"What a long way it is from one life to another, yet why write if not for that distance, if things can be let go, every before replaced by an after."

– Yiyun Li, *Dear Friend, from My Life I Write to You in Your Life*

TABLE OF CONTENTS

PREFACE

In *After: The Obligation of Beauty*, Mindy Weisel, through her fusion of language and art, both in the literal telling of her life experiences and in the process of her works of art, creates a new synthesis.

What is the nature of the second generation of Holocaust survivors? Bergen-Belsen was a concentration camp which had been turned into a Displaced Persons camp upon liberation by the British. It became the place of Mindy Weisel's parents' wedding, as well as her birthplace.

Mindy Weisel chooses not to speak of this inhumanity. "I can speak of seeking a purpose in living: an attempt at a fulfilling and

meaningful life in the face of such enormous tragedy. I have been living a life in search of beauty."

It was in the discovery of a pencil drawing by her father during his time in Bergen-Belsen, then a DP camp, of the sun rising "in such a bleak place expressed hope." At that moment she writes, "I fell in love with the power of art. Art can make you feel."

The great pleasure and depth of this book comes from the intertwining of paintings and reflections. "To express what is beyond language." And what is most unique in the art is the use of writing which underlies the visual creation. The layering. "Layers of emotion… color upon color." How for a year the artist's father was the focus, his Holocaust number tattooed on his arm in Auschwitz. She wrote that number on every paper and canvas she worked on, abstract work, and her "search for light and air and a place to put down his story."

And for her mother, who survived Auschwitz, for whom Mindy Weisel had lived much of her life, learning to live for herself after her mother's death was complex. Three months after her death, Mindy Weisel went to Los Angeles to sort through her mother's wardrobe. She returned to Washington with three of her mother's dresses. She wondered if the threads of her mother's dresses could be made into handmade paper. The paper, indeed, was made, with threads of her mother's dresses visible. And on these sheets of paper,

Mindy created the series "Lili, Let's Dance" – the memory of their shared sense of beauty held in these original works. And she was able to incorporate bits of the fabric into the paper. As she worked, she felt great joy and the memory of their shared sense of beauty.

There is much to learn from this artist, including her role in the larger contemporary world. Whether speaking at the U.S. Embassy in Berlin, or with artists about their own backgrounds, four whose fathers had been affiliated with the Nazi party: "Through the interpreter we exchanged information about our art, and our personal histories. They with their guilt, me with my sadness."

She learned of cultural events shared by Israel and Germany. I was reminded of the young German non-Jews who came to a summer Yiddish program in Lithuania and others from Austria, to work in the Holocaust Museum in Lithuania and to teach about Wartime events, in place of serving their required military time.

Mindy Weisel spoke at the Dachau Education Center to a large group of teenagers about "the survival of beauty and the obligation we all have to create a world of peace and harmony." She was asked by one: "How does our generation make sure this never happens again?"

Later, when she spoke at Oxford University, she said, "We can only move forward if we understand that the generations 'after' are not to be blamed for the sins of their fathers. The cycle of guilt and

blame, while understandable, is itself destructive and cannot serve as a basis for reconciliation."

We seldom, if ever, have as intimate a walk through the unique artistic process as the artist has given us here.

I have not spoken here of her profound work in glass, the ultimate source of light.

– Myra Sklarew

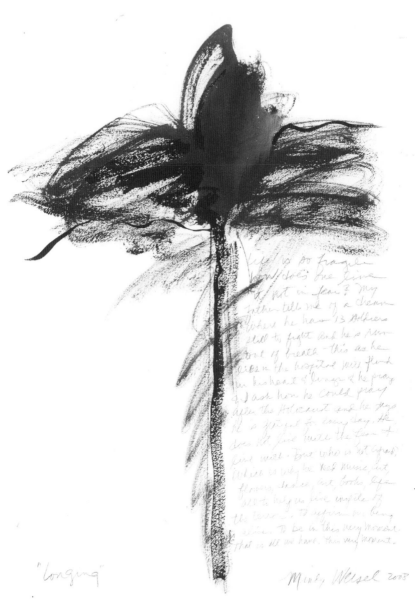

"Longing," 2008, watercolor, 36 x 24 in

Collection of Emily and Alfred Johnson

THE STORY I CAN TELL

A long time ago, I stopped wishing for a different past. One where the mother and father were not Holocaust survivors. When I started writing this book, over ten years ago, perhaps I would have emphasized my parents' stories more than my own. Yet, I feel that the horrors of the Holocaust are not mine to tell. As much as I believe this tragic history must never be forgotten, I also know that I am not the one to write about them. I am not the one to speak of man's inhumanity to man. Yet, I can speak of seeking a purpose in living: an attempt at a fulfilling and meaningful life in the face of such enormous tragedy. I have been living a life in search of beauty.

When I speak publicly, I speak about the survival of beauty. The importance of beauty in our lives. I do not speak about the stories I

heard growing up. It feels unbearable to share the stories my father still tells, rolling up his sleeves, exposing the Holocaust number on his arm: A3146. A as in Auschwitz. It is not in me to tell the story of how unbearable my mother's life in Auschwitz was. I was born into inherited trauma. I can only write of my experience, my own firsthand trauma, being raised in a survivors' family. Yet, I not only witnessed the heartache of survivors, I witnessed untold strength. Indescribable courage. I witnessed creation: creating a life out of shards so few, they could not fill a thimble.

What does finding beauty even mean? What story can I tell? Do I care to tell? How is it I believe in the kindness and gentleness of the world? How is it I believe in beauty as the genuine antidote to human pain and suffering?

In memory of my mother and in honor of children and grandchildren everywhere, I write this book. My mother believed in roses. I believe in art. My belief in beauty is an obligation, a duty, a responsibility, a great joy in fulfilling: Beauty: in living it, in creating it, in sharing it. This has been my purpose.

––––––

Among the first children born at Bergen-Belsen, Displaced Person's camp, January 1947, I had to find a self that was not bound by the Holocaust and the inhumanity my parents had endured. This book is a trace of my own struggle in finding beauty and meaning in the

face of a tragic history. I made the search for beauty, the expression of beauty, the belief in beauty, the theme of my life. Beauty, in all its forms. An aesthetic life was the only one I could imagine for myself.

We each have our own story. Mine is not about the Holocaust. Yet, as much as I had experienced the inherited trauma, history, damage and loss the Holocaust generated, I became an optimistic, creative person living a very fulfilled life. How did this happen?

There have been thousands of books written about the Holocaust: biographies, autobiographies, books on WWII. Poems, films, painting, sculpture, photography, music and dance all have been created in an attempt at trying to express the horrors of this history in search of a bit of light. Books have been written mostly by or about the survivors. Many survivors' children have written books about what they learned of their parents' experiences, including Art Spiegelman's *MAUS* and Helen Epstein's *Where She Came From*. These books are the story of *their* parents' experiences. I believe it is time for my generation to write our own experiences.

I believe many books will be written by survivors' children. Books that will be firsthand experiences of what it meant growing up with Holocaust survivor parents. They will not be books about our parents' history and trauma but books that will explore our own search for meaning in the face of our inherited tragic history.

I have spent my life in search of what I value and believe in. *Where*

do I belong? Who am I? How do I find a measure of peace, meaning and beauty in life? How did I survive the black hole I was born into? There was no map for living. We, the survivors' children, had to become our own cartographers.

I identified strongly with a passage I read, recently, from the book on Joan Mitchell, one of my favorite artists, written by the art historian Judith E. Bernstock. Joan Mitchell was great friends with Samuel Beckett. The two explored the existential despair of feeling like an outsider.

> Mitchell's feelings are comparable to those of Beckett, for whom anxiety is an ineradicable part of the human condition. Man is at home neither with people nor alone. Beckett's early concerns with exile and alienation… are reflected in his later focus on a search for the missing self. Mitchell's self image as an outsider… looks at maps in search of her identity.

THINGS HAPPEN

Inspired by Helen Epstein's now classic, *Children of the Holocaust*, I discovered an entire generation of survivor children who shared similar psychological and emotional issues. I recognized that for survivors' children, there was hardly any guidance in learning to recognize one's emotions or needs. This was a major revelation. After all, what did any of us have to complain about? We were not starving in Auschwitz. According to our parents, we were not missing anything. There was no space for our own anxieties or our own sense of loss. We were an entire generation looking at our parents' faces to see how *they* felt. To make sure we could do everything in our power to make them happy – to erase their longing. Their suffering. Our first real language was our parents' faces. We recognized their feelings and made them our own. We

were supposed to "understand." An entire generation of children who were supposed to understand that their parents were damaged and that they were coping as best they could. It was clear our demands were expected to be few. And, of course, we were never allowed to express our anger. Like so many others with my background, I buried my feelings.

Do we ever get used to the feelings of loss? Time supposedly heals all wounds. Does it really? Or do we take that time and take that loss and turn it into something else – something that takes the shape and the form of our loss? Life is the source of art.

I took my sadness and made paintings. I took my desire for happiness and made paintings. I took the experiences I had and made paintings. I took the travels and made paintings. I took the memories and made paintings. I took the poem, the music, the dance, the film, the love, the fantasy – and made paintings. I took the flower, the sky, the ocean, the child, the magic, the angels and made paintings. Abstract marks that hold my life. A life beyond language.

Family life was unpredictable. My mother, with her great smile and laugh, suddenly would enter a place of great sadness. I only needed to take one look at her face and know she was not "present." She was lost in a lost world. This sadness and sense of loss created an atmosphere where I felt constantly in the presence of absence. An anxiety settled in my bones early on.

In spite of the sadness and sense of loss that was present most of my life, I witnessed great courage and strength. Rose bushes were planted; English was spoken – with that wonderful European accent. A belief in education, reading and travel was encouraged. Piano lessons and tennis lessons were given. An openness about one's beliefs and traditions were maintained. A sense of beauty was upheld as a necessity not a luxury. Having flowers in the house was important. I have tried to sift through the sadness and the joy, and have ended up with a heart mostly full. The big black hole of childhood is now a small pebble. The impending doom I felt for so many years has been surrendered to the universe. I have accepted what I am to be held responsible for, and which is not mine to absorb.

My father was right to say, "Mindeleh, if you live ˄ ''˙ ⸝ ˑgs happen. Enjoy what you can."

How does one live a life? It depends who you ask. The wise doctor I was seeing in my twenties, Dr. Berl Mendel, said, "One hopes at the end of one's life one has more good days than bad days." I loved his answer. It felt honest and real. When my mother died, twenty years later, I went to see him again: *but, Doctor Mendel, my mother had a hard life. A year in Auschwitz was not a picnic.* His answer was resolute: "I trust she still had more good days than bad ones." I cried that entire fifty-minute session. When I drove home, I called my father and asked him the same question: How does one live a life? "Mindeleh, if you live a life, things happen. You are

living. Period." He is right. To be alive is to feel fully. No one is spared sadness.

Yes, life is living. It takes strength to live. It takes courage and stamina and luck and a full tank. Yet, who does not walk around with half a broken heart? I feel it is what we *do* with the other half – **the half NOT broken** – the half that still beats with the excitement of possibility – that makes life worth living.

MOMENTS OF BEAUTY

I call a dear friend to suggest a walk. We are both feeling a bit despondent as we start out, discussing how the constant "breaking news" on our cell phones and iPads do not give us a break. We feel anxious just turning on the TV. This constant interruption, we say, of our personal moments of peace and quiet engender a great deal of anxiety.

While walking in our charming Jerusalem neighborhood, I stop as we pass a flowering jasmine tree which fills me with a longing for my mother. Its fragrance reminds me of her White Shoulders perfume! As we continue, I stop to point out a pale purple flower; roses in the most unusual shade of soft coral and small delicate yellow buds in the center of a tiny white flower. By now, I notice

my friend is still "in her head" while I am starting to feel a sense of excitement and wonder at the beauty around us. We were in better spirits as we said our goodbyes. Reflecting upon our walk, I had a flashback to my first art class in college. The professor's opening sentence: *"To become an artist, and to live life fully, one has to see."* Seeing is key.

Is *"seeing"* an inherent ability in each of us, or is it in the specific nature of the individual? Is becoming aware of the beauty that surrounds us, even in the direst of moments, something that can be taught?

A close friend of mine goes fly-fishing. It is his passion. Another hikes and can distinguish one rock from another; Another meditates as well as reads voraciously; another finds comfort looking at the sea, while another tells me she feels "differently" after baking bread. Perhaps it is really simply stopping and paying attention to an activity that takes us out of our own complicated selves that can give us respite. The beauty we find is the beauty we search for.

Whether "inherent" or not, I feel it possible to find solace in what we can create as an antidote to the harshness of the world outside ourselves.

The great book, *Life and Death in Shanghai*, by Nien Cheng, is an autobiographical account of an elegant, wealthy woman's imprisonment during the Chinese Cultural Revolution. Nien

Cheng describes how her life was stripped away, yet her desire to create something of beauty stayed constant during her long confinement. One chapter, especially, inspired me greatly. Ms. Cheng describes how she no longer could tolerate the ugliness of the bleak gray cement walls of her cell. One morning, she decides to not eat her meager meals of rice for two days. Saving the rice, she started wallpapering her cell with the rice, which dried into a lovely white wall covering. She then befriends a spider in her cell, and she finds joy and comfort.

We do have it in us to search for moments of beauty that can sustain us. It is essential that we find it, so as to survive the daily "breaking news."

"Breath (The Why of It)," 2014, oil on canvas, 149 x 169 cm

Collection of Emily and Alfred Johnson

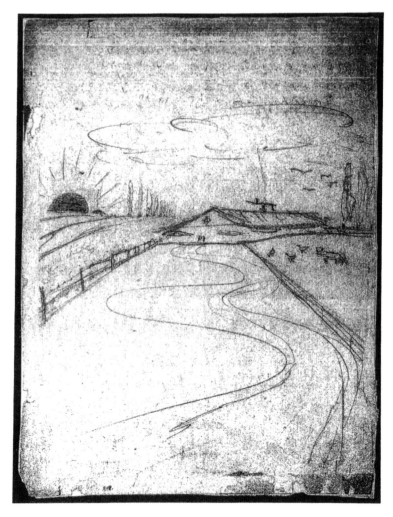

My Father's Drawing –
in Bergen-Belsen – "Son Rising"

MY FATHER'S DRAWING

Ironically, my first awareness of actually being moved to tears by a work of art, was not in a museum nor an art book, but from a drawing my father had done, after the war, in Bergen-Belsen in 1946. My father's drawing. My father had never spoken of ever having made any art. In reality, except for this one drawing, he hadn't, not before nor after.

In 1949, among the few things my parents brought to America with them was an old black leather suitcase. I loved this old suitcase: the smell of it and the feel of it. I loved looking through the suitcase and seeing a few old photographs, as well as some Yiddish writings kept in a faded black leather journal. One day, alone in my room, looking through the suitcase, I found a Yiddish journal my father

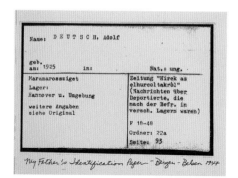

My father's displaced persons registration card

had kept after the war. Among the thin yellowed papers, a drawing fell to the floor. It was simply beautiful.

I ran to my father with this pencil drawing, breathless. The drawing, in fine pencil, was of a sun rising up over a barn. Outside the barn, animals and trees lined the walkway. The marks were abstract and simple. There was a strong sense of perspective, and the work seemed to hold a great deal of emotion. I was fascinated. I had never seen my father draw anything.

My father recollected that one clear, cool morning, after he and my mother were married and still living in the Bergen-Belsen DP camp, the view of the sun rising made his heart sing and the need to draw what he was witnessing was all consuming. When he told the story, I felt like crying. A sun! A picture of a sun rising in Bergen-Belsen. To capture the simple joy of the sun. My father was moved to make

a mark. Remarkable. This drawing of the sun rising in such a bleak place expressed hope. Roland Barthes writes that *love* is found in a moment of *recognition*. In that very moment, alone with my father, and this drawing, I fell in love with the power of art. Art can make you

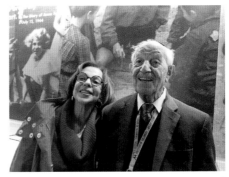

My father and I at The Simon Wiesenthal Museum of Tolerance, Los Angeles, California, where he speaks on the Holocaust

feel. I believe this *recognition* was the first of many, confirming my desire to paint. To make art. I didn't know it then, but now, looking back, I realize that seeing my father's drawing was my first awareness that a drawing, a mark on a piece of paper, could make one feel something. The drawing expressed the power and ability of art to hold onto memory, experiences and emotion.

My mother framed this drawing in a beautiful cherry-wood box frame. This work, in the same frame, has hung in every house I have ever lived in, for the past sixty years.

My father had found a way to express what he was seeing and feeling after the war. This drawing opened my eyes and heart to the reality that art and life, intertwined, was meaningful. And there began my search to understand both.

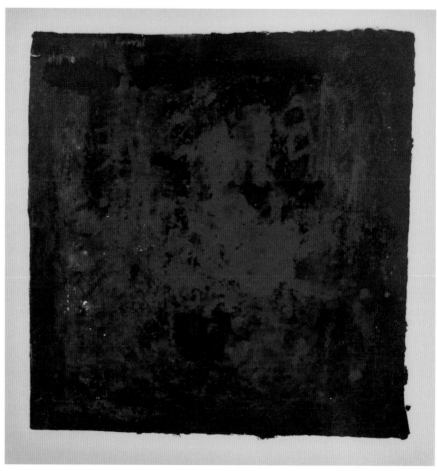

"Song of Blue," 2015, watercolor and gouache on handmade paper, 45 x 45 cm
Collection of Ariane Weisel Margalit

"To become aware of the ineffable is to part company with words… The tangent to the curve of human experience lies beyond the limits of language. The world of things we perceive is but a veil. Its flutter is music, its ornament science, but what it conceals is inscrutable. Its silence remains unbroken; no words can carry it away."

"Awe is an institution for the dignity of all things, a realization that things not only are what they are but also stand, however remotely, for something supreme. Awe is a sense for the transcendence, for the reference everywhere to mystery beyond all things."

– Rabbi Abraham Joshua Heschel
 God in Search of Man, 1955

Making Marks

of survival
of loss
of longing
of love
of memories
of experiences
of anxiety
of fear
of journeys
of joy
of music
of dance
of light
of beauty

MAKING MARKS

I start each painting by writing on the paper or canvas I will be working on. I write directly in pencil, until words start losing their meaning. I then mix my paints and start making marks. Abstract marks that seem to be coming directly from my heart. My head is definitely not involved. I write and paint out of a desire to coherently express what I am feeling. To form the unformed. To make order out of a deep internal disorder. I do not really know what I am feeling until it gets expressed and those feelings become "real" in the process of making art. I often feel that I am simply a medium. A vessel that overflows with everything that has been poured into it. There is no place else to put it all except in my work. There is never a conscious "preconceived idea" as to what I want to paint. I go into the studio, sometimes with desire often with inspiration,

and usually with longing. Best of all is when I go into the studio with a sense of "wonder."

Rabbi Abraham Joshua Heschel, a great Jewish philosopher, has said that "an artist should not have a memory" – meaning that each time an artist approaches his or her work it should be as if they are painting for the "first time." The emotional honesty of a painting has to be just that – honest. Ironically, Hans Hoffman, the great German abstract painter and teacher, expressed a similar philosophy in the 1940s. Hoffman stated that an artist cannot concern himself with "style." The energy used worrying about one's "style" takes away from the necessary abandon and surrender one has to give to one's work during the process of making art. One needs to express what one is feeling so that the viewer might feel it, as well. My search while working is an attempt at an emotional clarity. I am not concerned with painting an accurate depiction of anything but rather what life feels like. To express what is beyond language.

There is a point, in the process of working, where the "head" does take over. Decisions have to be made quickly: a touch of red here, a touch of blue there. It is an artist's job to make the work "sing" with whatever tune is playing in their heart at that given moment and pleases the eye. There are days where there is no song. No notes are being played in one's head or heart. It is, at that time, that it is the hardest to "go in there" – into the studio – and into one's self. There are days when the prospect of being alone in a room

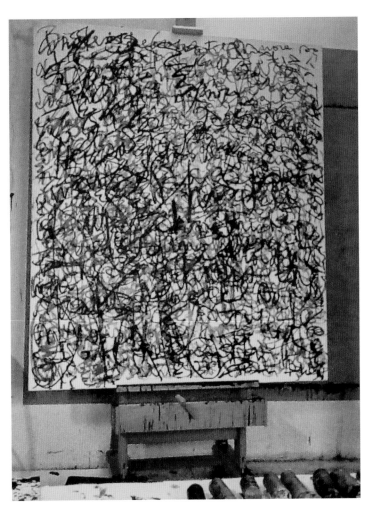

Writing first all over canvas
before painting till words lose
their meaning ———

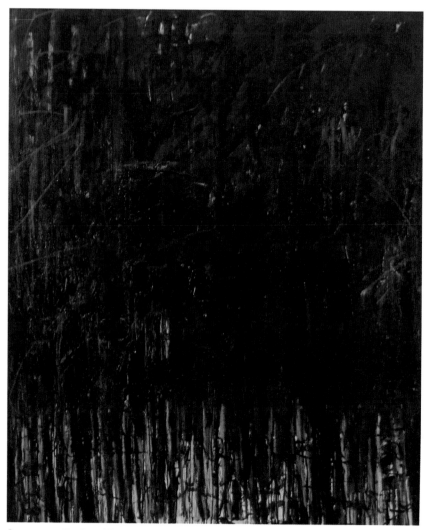

Permanent collection of The Israel Museum

"Gods Tears" oil on Canvas
7' high x 5' wide —
Israel Museum Collection

is nothing short of impossible and terrifying. Yet it is even harder staying out of that room. If I don't go to the studio and give the work a chance the certainty of *nothing* is guaranteed. To go is to believe in possibility.

To make art is to accept the responsibility of being alone; of pulling work from a deep place inside oneself; from being sensitive and open to the world. The great artist Louise Bourgeois, when asked, at the age of 90, how she felt about her life, said, "It's a great privilege to make art."

There are endless varieties of artists: Conceptualists, Realists, Performance Artists, Impressionists, Cubists; on and on. I fall into the category of Abstract Expressionists. I make marks that express an interior life. What I paint is not a reaction to what I see in the outside world (though I am quite inspired by a certain light, flower, ocean...) It is, rather, my desire to capture the emotion in response to the beauty of the moment and the experience: love, longing, gratitude, anger, and the internal chaos within. I paint in an attempt to create some form of sense and order out of life.

A painting is not finished until it holds layers and layers of emotion: layers and layers of lights and darks; ups and downs; color upon color. The work is complete when it survives the process of painting. The search for an emotional honesty, while working, has always been a dominant force. Were I not painting, I feel the unexplored

emotions would have consumed me. I am as surprised as anyone by the depth of expression. Most of all, it is work led by my heart.

My work is about feelings. Originally, the paintings were reactions to my personal history. In 1979, I became obsessed with my father's number A3146, tattooed on his arm, when he was 19, in Auschwitz. I wrote his number endless times on every single paper and canvas I worked on that year. The work was abstract dark layered with blue indigos and black. Only now looking back at these dark paintings do I recognize a genuine search for light and air and a place to put down his story. Each series after the A3146 series seemed to call forth a different memory or experience. The work always, and still, feels as if it has a life of its own. After that year of dark work, however, I became emotionally spent. I had to rest for months to recover. The physical and emotional energy, and the emotional probing that was demanded of me, left me completely depleted. I was exhausted and I could not go to the studio for months.

I cannot go for long without time in the studio: painting; searching; mark making; trying to find meaning in the day; in the moment; in life. Life makes "sense" when I am making work. When I am not involved in creative activity, there is a strong sense of "free-floating anxiety": a feeling that I am wasting my time, wasting my energy and not making full use of the moment.

Life has given me plenty to paint. And painting has given me a way to live a life.

How To Become a Painter?

A painter paints.
Simple: paint.

To be called an Artist
with a Capital A
well,
that's years.

Of tears.

Working
with no fear,
OK, yes, terror
but, still…

Alone.
Can you be alone?
With…
 fill in the blanks.
Alone?
You can't be alone?
 Forget it.

Dirty brushes
 clothes
 nails (even with gloves)
 floors
 turquoise everywhere.

Forget talent.

If you can
go in there
yell, cry, dance, laugh, destroy, rebuild
start again and again and again and
again.

Do not think.
 Only feel.
You can't feel?
 Forget it.

Re:Art

I love the moment —
maybe I live for the moment
when a work is about to
die & you gather all your
energies & passions within
yourself & you make a
mark that says LIVE
DAMNIT LIVE & it
lives. Maybe thats what
Art is all about. living

Sept 21, 1979

Art has got to show the struggle
& end up mysterious &
—magical in feeling . . .
which mark came first?
How did it get to its final
impact? — how did it hold on
to the feeling? I have a
muse — it helps the work —

· leaving studio —
exhausted

Mindy Weisel

Artist Journal

Collection of the artist

NEEDING AIR

I find myself often *needing air* at the strangest of times. I could be in a lovely park on a spring day and be overcome with that feeling. It usually lasts a moment or two, and then passes. There was one incident, however, where "needing air" became all-consuming.

My grandson, Ely, five years old at the time, had slept over, and I was rushing to get him to nursery school in the morning. We stepped into the elevator of our lovely apartment building in Jerusalem and I was overwhelmed by a strong *burnt* smell. It was unbearable and we took the stairs instead. At Ely's school, kissing him goodbye on his sweet head, I felt I could not get to the studio fast enough.

I felt very disoriented when I got to the studio. Where was I? In an attempt at settling down, I started writing in a new red drawing journal. I wrote: *She needed air. Where was the air?* I wrote, I drew, I painted, over and over again AIR. As I worked, I started including my mother's name Lili. Lili needed air. At that point, I realized that the strong smell in the elevator was what I must have imagined to be the smell of Auschwitz. Not to mention three days in a cattle car getting there. There was no *air*.

After I finished writing and painting in the red journal, I sat quietly, thinking that perhaps there are stories we truly never get over... even if we haven't lived them ourselves.

Mindy Weisel

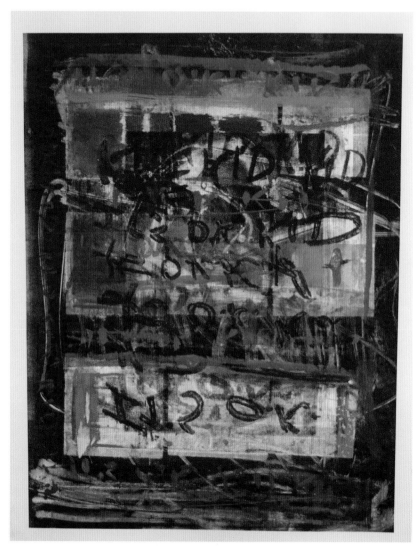

Dr. M's last words to me before he died
"It's O.K. Kid" 1995. A PLACE FOR MEMORY SERIES

An Aloneness

What was I
lonely about
before I
realized I am
lonely now?

An aloneness
that has no
reason.
Nothing I know
about
anyway.

An aloneness
that I am
almost
comfortable
with.
An aloneness I
am not really
used to.

An aloneness
that surprises
me by its
fullness.
Such a lonely
full of empty.
Alone is its own
world.
Not high, not
down. Not
anything
alone.

And nothing.
Nothing.
Nothing.
Nothing.
Nothing. Nothing.
Will make it less
so.

"So much has been written about the darkness and horrors of the Holocaust. As daughters of Holocaust survivors, we were buds growing from the nearly dead branches of our parents. But we are the daughters of the future. We turned to the artistic and the creative expressions of life's beauty in celebrating their survival."

– Hadassah Lieberman

"Sensitivity to separation, feelings of mourning and guilt, the desire to protect their parents and suffering people in general, are common threads running through the fabric of the lives of survivors' children. They share feelings of excessive anxiety, bereavement, over-expectation and over-protection."

– Dina Wardi, *Memorial Candles*

MY MOTHER'S BACK

Painting has a life of its own. It takes its time in presenting itself. In 2004, I had a difficult and unusual painting experience. I had started a new work on a six foot by five foot stretched canvas. For almost an entire year, from 2004 to 2005, I could not seem to find my way to completing this painting. I usually work quickly, stopping when I feel I have said enough. It took an entire year to finish this one large painting and almost as long to even become aware of *what* I was trying to say. I simply could not complete this work because I could not understand this work. One section of the painting seemed to fight me with every mark I made.

I went to the studio several days a week, yet, week after week, month after month, it seemed I was in the same rut: I would leave

the studio excited, certain that I had finished the work, only to come back the very next day and be disappointed: either the paint had not dried as I hoped, or I felt the painting was not saying anything. I could not understand the work at all. Why was it so uneven? One part of the work was smooth, another part insisted on texture; why one part dried beautifully, with the color as fresh as when it was first applied, and another part of the work remained dark and uneven. I had no handle on the work at all.

It was disheartening, after months of working, to return to the studio and be disappointed, time and time again. Though the painting process requires patience – I cannot hurry a work – this particular endless work process was not "my normal." It did not usually take this amount of time and energy in finding the painting's voice. What on earth was I trying to say that was eluding me?

I kept working, in spite of the reality, that no matter my intention, the majority of the painting stayed smooth and fresh, layer after layer, with an inner layer of light surviving the painting process. Most of the painting stayed true to the blue palette I was working with, so why did this one section, just one, get darker and darker and more textured as time went on? This dark, textured section felt like a great mystery. A small section was keeping the work from being cohesive and making sense. Why? The top part of the painting just refused to become clear. I felt there was no "unity" in the work, and I stayed frustrated and confused working on it. Despite my inability to get a handle on the work, I had no desire to abandon it.

Several months into this, while walking to the studio, I had a powerful flashback. I was engulfed by a vivid memory: of washing my mother's back. While a young girl, living at home, I would wash my mother's back. A daily activity I didn't particularly mind, yet, now, as I was thinking about it, I could not imagine asking any of my three daughters to wash my back.

Soon after we moved into our first house in Brooklyn, from a small apartment on the Lower East Side of Manhattan, part of our new home went up in flames.

One morning, my mother, convinced she smelled gas, called an electrician. My younger brother and I were playing in our new family room when the electrician arrived. I was eight, my brother two. We were happy.

While my brother and I were playing, a great explosion suddenly erupted from the room my mother and the electrician were in. A powerful blast rocked our home – and our lives. Smoke and flames spread quickly. My mother, with her head scarf on fire, yelled for us to run out of the house.

Maria, our Italian neighbor, with whom we shared a front porch, called the fire department and ran out of her home with blankets. My brother and I watched, as Maria rolled my mother to the ground, wrapped in the blankets to stop the flames from going down my mother's back.

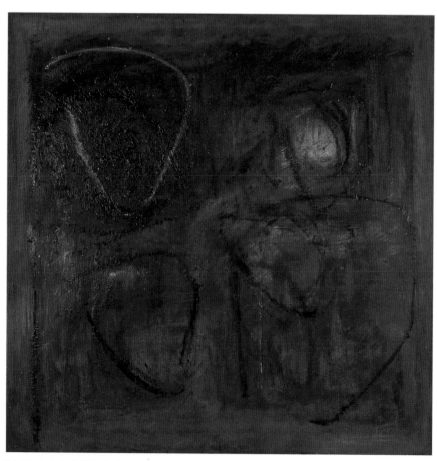

"My Mother's Back," 2004, oil on canvas, 72 x 72 in
Collection of the Vine family

Terrified, out on the street, we soon heard the ambulance. Our father arrived soon after, his face sad and frightened. He got into the ambulance with my mother, reassuring us that he would be back home later that night. My brother was taken to my aunt and uncle who lived in the duplex upstairs of our home, while I was taken to my great aunt in another part of Brooklyn.

My mother was taken to Bellevue Hospital's burn unit, where she stayed for three weeks. I tried, and succeeded, in not crying, as I was taken from home, after the fire. The world seemed to become very quiet. My mother and father were gone. I was at my great aunt's house. No one had anything to say – myself included.

I was terribly lonely and worried about my mother. I would cry myself to sleep, once everyone else went to bed, in the little alcove bedroom that I slept in. I would finally doze off as I watched the shadows on the ceiling made by the window blinds. The shadows intrigued me.

At eight years old I had experienced my own "first-hand trauma." It was not the inherited stories of the Holocaust that were told to me by my parents. This was a new reality.

I witnessed my mother go up in flames. The terror and anxiety that I could lose my mother as quickly as she lost hers, was fierce.

We often believe we can put things "behind us." Yet, my paintings prove me wrong more often than not. I am always surprised by the

end result of a painting. I have no idea the *feel*, the *look*, nor the content of the work, before I start work. The emotional content of a work presents itself during the process of painting. I just paint, layer by layer, without a preconceived idea of the direction the work will take. I trust the painting's journey. I love the process of mark making. Each work seems to have a life of its own. Each mark seems to hold a layer of emotion, memory, and experience, transferred directly from somewhere inside myself. That is how I paint.

After my mother's fire in Brooklyn, my mother's left shoulder remained deeply mottled, textured, dark and scarred. Remembering that daily activity of washing my mother's back, my heart started to race and I started running to the studio. As soon as I got there, I looked at the upper left part of this painting I had been struggling with and recognized the dark shape as my mother's scar, on my mother's left shoulder. I understood the painting as soon as the memory of washing my mother's back surfaced.

As soon as I recognized the shape, the texture, and why it was so different from the rest of the work, I stopped fighting the painting, completed it, and titled the work, "My Mother's Back." The artist knows when a work is "done," when it becomes an aha moment of recognition.

After finishing the painting "My Mother's Back," I started reading *The Drama of the Gifted Child*, by the psychoanalyst Alice Miller.

Miller writes about a memoir written about the sculptor Henry Moore, in which he describes having to rub his mother's back with oil for rheumatism. Alice Miller writes:

> Reading this suddenly threw light for me on Moore's sculptures: the great, reclining women with the tiny heads – I could now see in them the mother through the small boy's eyes, with the head high above, in diminishing perspective, and the back close before him and enormously enlarged. This interpretation for me, demonstrates how strongly a child's experiences may endure in his unconscious mind and what possibilities of expression they may awaken in the adult who is free to give them rein. Now, Moore's memory did not concern a traumatic event and so could survive intact. But every childhood's traumatic experiences remain hidden and locked in darkness, and the key to our understanding of the life that follows is hidden away with them.

Bergen Belsen, 1948

THE PRESENCE OF ABSENCE

April 1944, Hungary: my mother, one of eleven siblings, and her entire family were taken to Auschwitz. Nazis stormed their home during their Passover seder meal, threw everyone into cattle cars and took them to concentration camps. My mother was the only woman left in her family: Her mother and four sisters and their children were all killed in the gas chambers at Auschwitz.

My father's family was also taken to Auschwitz during the spring of 1944. He was from Sighet, Romania. He was among the youngest in his family and was rounded up with his parents and a younger brother and sister, who were killed as soon as they arrived at Auschwitz. Out of eleven siblings, nine of them survived the war. Some brothers survived Labor Camps; some sisters and brothers

L410

Bergen-Belsen

16

Name, Vorname	Datum	Geburtsort	Name, Vorname	Datum	Geburtsort
Czarwa, Hilda	19. 3. 26	Wielkie Hajduki	Dawidowicz, Dora	26. 6. 28	Czech.
Czarna, Cesia	2. 1. 14	Dzialoszyce	Dawidowicz, Iloni	28. 2. 24	Ung.
Czarnes, Fela	19. 8. 18	Sosnowiec	Dawidsohn, Malka	5. 2. 17	Belrzyc lubelski
Czarnota, Fran.		Polska	Dawidowicz, Fani	11. 6. 25	Rumun.
Czernikowska, Fania	1925	Wilno	Dawidowicz, Etel	15. 1. 23	Ung.
Czernikowska, Chaia	1910	Wilno	Davidovics, Etel	25. 4. 19	Ung.
Czestochowska, Ala	10. 5. 18	Lodz	Dawidsohn, Estera	10. 10. 23	Belrzyc lub.
Czarnobroda, Cenia	15. 5. 14	Tomaszow	Dabrowski, Moniek	13 lat	Polska
Czapnik, Michal	18. 7. 23	Krakow	Den, Halina	7. 8. 22	Radom
Czerniak, Edzia	8. 8. 17	Pabianice	Delta, Alegra	19 lat	Korfu
Czeninski, Abram	24. 2. 25	Jedrzejow	Denta, Luya	35 lat	Korfu
Czerwonogora, Cela	16. 12. 18	Brok nad Buglem	Deisy, Brudo	18. 8. 26	Saloniki
Czernichow, Hadasa	1909	Wielka Brzostowica	Demba, Estera	2. 1. 20	Czestochowa
Czerny, Hela	14. 1. 20	Lodz	Deak, Ilona	22. 4. 09	Ung.
Czerny, Szyja	5. 6. 22	Slawkow	Derblich, Iohanna	10. 8. 12	Czech.
Czernikowska, Hania		Wilno	Derda, Stanislaw	34 lat	Polska
Czestochowska, Sara	10. 5. 15	Lodz.	Deimeut, Helene	12. 7. 25	
Czin, Szili	20. 12. 24	Ung.	Deimet, Elza	12. 1. 96	Czech.
Czin, Szili	20. 12. 24	Ung.	Dekner, Nusana	5. 7. 27	Budapest
Cziiter, Agnes	23. 12. 21	Rum.	Dente, Alegra	8. 9. 26	Karhira
Czulkowski, Heinrich		Polska	Dentez, Sandor	28. 5. 26	Budapest
Czyzyk, Mina	5. 8. 25	Sandomierz	Dentel, Rozalia	6. 9. 27	Targu Amres
			Deutsch, Olga	20 lat	Jugoslaw.
			Deutsch, Ruta	26. 12. 05	Pabianice
Domanski, Chil	8. 11. 17	Podebice	Deutsch, Tereza	18. 10. 24	Nagyvarad
Dawidowicz, Rozia	5. 5. 24	Lodz	Deutsch, Olga	14. 12. 30	Ung.
Dalezman, Regina	1. 1. 22	Sosnowiec	Deutsch, Lili	4. 4. 21	Rumun.
Dabiak, Miriam	15. 12. 25	Polska	Deutsch, Margit	12. 1. 29	Ung.
Dabrowiczka, Hela	5. 5. 14	Zdunska Wola	Deutsch, Manci	12. 8. 26	Rumun.
Dadier, Julien	20 lat	Polska	Deutsch, Ilona	28. 4. 23	Sombathely
Dafner, Gita	18. 7. 28	Niwka	Deutsch, Magda	5. 6. 24	Zahalowo
Dafner, Rozia	23. 11. 23	Sosnowiec	Deutsch, Jolan		Bratislawa
Dafa, M. Sara	3. 4. 17	Kaballa	Deutsch, Ida	15. 8. 09	Czech.
Danzyger, Chaim	2. 1. 20	Czestochowa	Deutscher, Stella	25. 5. 19	Krakow
Danzyger, Fajwel	21. 8. 18	Czestochowa	Diament, Estera	1917	Ostrowiec
Danziger, Kiwus	8. 3. 45	Bergen-Belsen	Diament, Magda	27. 9. 18	Bratislawa
Danzigier, Mania	10. 3. 24	Stopnica	Diament, Cenia	20. 4. 27	Lodz
Danzigier, Icek	3. 7. 19	Warka	Diament, Gina	26. 6. 27	Lodz
Dabrowicz, Cenia	20. 5. 17	Czestochowa	Diament, Helena		Czech.
Dajtelzwelg, Cipa			Diament, Mina	20. 7. 19	Lodz
Damm, Hedwig	10 lat	USA.	Diament, Zosia	14. 10. 18	Czestochowa
Damm, Berta	42 lat	USA.	Diament, Bela	25. 12. 22	Lodz
Damfbret, Irene	13. 7. 22	Lodz	Diament, Mofek	4. 5. 27	Lodz
Daniel, Marie	8. 4. 23	Saloniki	Diamanstein, Sari	17. 9. 18	Ung.
Daniszewska, Chiena	20. 2. 24	Smorgon	Diamendstein, Rachel	9. 8. 20	Rum.
Danon, Serena	16. 11. 27	Dubrowina	Diamant, Gertrudda	6. 10. 24	Bratislawa
Danon, Stella	17. 4. 06	Dubrowina.	Dicker, Etnel	26 lat	Ung.
Danzi, Teres	14. 4. 10	Mikulas Czech.	Diczer, Dora	28. 12. 29	Ung.
Danziger, Mania	10. 3. 24	Czestochowa	Dimani, Artur	26. 10. 23	Ziwiercie
Danziger, Kiwa	8. 3. 45	Bergen	Diner, Salo	24. 8. 14	Ung.
Danziger, Gosek	3. 7. 19	Czestochowa	Duinszkein, Lonski	48 lat	Ung.
Dabrowska, Stanislawa	27. 4. 11	Warszawa	Dunski, Chaim Lajb	30. 11. 11	Bendzin
Danzyger, Dora	1921	Lodz	Dün, Frida	15. 8. 17	Krakow
Danker, Stefan		Polska	Domowicz, Klara	8. 9. 19	Pabianice
Danzyger, Edith	13 lat	Slovska	Dobronska, Bronia	1920	Lodz
Danzyger, Rubin	20. 8. 24	Bendzin	Dobusz, Marjem	9. 5. 00	Warszawa
Daoch, Ilons	25 lat		Dobinski, Czerwak	21 lat	Polska
Daros, Casimir	26 lat	Polska	Dozel, Maurice		Francia
Derwisch, Teresa	8. 10. 22	Kiszbirt	Dozcz, Rozia	20. 10. 29	Pabianice
Dassa, Rena	20. 12. 25	Kawalla	Dojcz, Frania	12. 6. 26	Pabianice
Daskal, Roszi	8. 4. 23	Czech.	Dolmas, Salomon	5. 5. 26	Saulne-Czech.
Dausch, Edith	18. 11. 27	Ung.	Domber, Edith	18. 2. 23	Ung.
David, Olga	1925	Czech.	Domanska, Hela	23. 7. 22	Lodz
Dawid, Regina	19. 9. 19	Tarnow	Domke, Ilze	2. 10. 26	Szczecin
Dawid, Bella			Donath, Ilonka	25. 3. 13	Ung.
Dawidman, Hanka	10. 10. 25	Ilza	Donersztein, Helena	1914	Sosnowiec
Dawidman, Mirka	9. 12. 22	Ilza	Dorf, Regina	20. 8. 19	Krakow
Dawidowicz, Katerine		Koszyce	Dorf, Dora	5. 10. 23	Krakow
Dawidowits, Rita	2. 1. 26	Vel. Serlus.	Dorf, Rozia		
Davidovits, Helena	26. 5. 23	Vel. Serlus.	Dorf, Regina	20. 10. 21	Krakow
Dawidowits, Margit	15. 9. 17	Ung.	Dorf, Rosa	3. 10. 23	Polska
Davidowics, Malcsi	29. 12. 20	Ung.	Dorfman, Bruno	16 lat	Polska
Davidowites, Margit	6. 1. 20	Ung.	Dorocheck, Mania	23 lat	Polska
Dawidowics, Sari	15. 2. 24	Rumun.	Drajlinger, Jozef	23. 3. 26	Nordhause
Davidovics, Malcsi	20 lat	Polska	Dryiman, Mina	10. 5. 24	Beuthen
Davidowics, Herszon	9. 7. 28	Czech.	Drach, Elisonora	26 lat	Ung.
Dawidwitsch, Erscch	18 lat	Ung.	Drall		Ung.
Dawidowics, Rosi	5. 3. 27	Czech.	Dreksler, Frania	28. 5. 07	Koziglown
Davidowics, Bela	22. 5. 27	Rumun.	Dreksler, Moniek	18. 11. 15	Dabr. Gorn
Dawidowics, Roza			Dreininger, Edit	11. 7. 21	Ung.
Dawidowics, Edyth	18. 4. 24	Koszyce	Drajer, Riwka	12. 10. 25	Krasny Staw
Dawidowics, Regina	15. 9. 28	Rumun.	Dregala, Cecila	24 lat	Polska
Dawidowics, Fela	10. 12. 12	Ozorkow	Drelich, Pesla	8. 6. 23	Sosnowiec

My mother listed in Bergen-Belsen, 1945
Lili Deutsch

My parents in DP camp Bergen-Belsen, Germany 1948

survived German and Polish concentration camps. After the war, much of his family found each other in the Displaced Persons camp at Bergen-Belsen, Germany.

Bergen-Belsen was liberated by the British in April 1945. The British kept records of what they witnessed when liberating the concentration camps. There were photographs of the horror they encountered upon liberation. The British also printed lists with names of the survivors. Lists of the women survivors, list of the men survivors.

After being liberated my mother was taken to the hospital set up at Bergen-Belsen Displaced Persons camp. My father, all of twenty at the time, while checking lists daily to see if siblings had survived, came upon my mother's name. My mother and father were cousins. My aunt, Ida Deutsch, had the same last name as my mother's and both names were on the list. My father went in search of them and found them recovering together at the hospital in Bergen-Belsen.

My father, tall and emaciated, was still recognizably handsome and young. My mother, though ravaged by the camps, was still beautiful with her high cheekbones and elegant face. They recognized each other, fell in love, and were among the first weddings held at the Displaced Persons camp in January 1946. I was born a year later: January 1947.

After the war, every survivor had a story. My father's was nothing short of miraculous. One thousand men were taken from the camp on the now legendary January 1945 Death March in Eastern Europe. He walked in the snow, taking off shoes of the ones who died as they went along. Six days of walking in freezing cold. Out of the one thousand men who started out together, he was one of sixty men who survived. What my father was left with after such brutality was, and continues to be, an attitude of unfiltered joyful gratitude. Day after day. He complains about nothing. Not a thing. He also does not worry too much about anything but his own survival. He is a survivor. As a friend once said, "Your father could fall off the ninth floor and he would certainly land on the eighth."

After

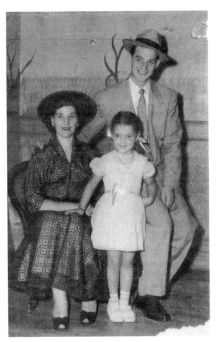

My parents & I - at a wedding -
Brooklyn, New York 1951

My father, the youngest surviving son of eleven children, knew how to take care of himself from a very young age. I wouldn't say "since childhood" as it doesn't sound like he had one. Poor, Ultra-Orthodox family, he remained the handsomest, most charming, and narcissistic of them all. As a young boy my father knew how to use his inherent charm to survive. Being among the youngest in his family, he was left to his own devices and learned to fend for himself very early on.

My mother, Lili Deutsch, was a very proud, attractive woman from a fine home near Budapest. After the war, she saw herself as "displaced royalty." My father, on the other hand, from a poor home in Romania, was simple in his tastes and desires. My father would say, "You can only eat with one fork at a time."

As a young child, the bar for living was set high. I do not know of any survivors' children who talk about "childhoods." Who had a childhood? We had parents who had survived hell and we, their children, felt responsible for their every happiness. In my parents minds I had everything I needed. There was no reason, according to their thinking, to be sad, lonely, tired, hungry, angry – all that was expected was gratitude for being in America. What could I possibly *need*? I had shoes, a bed, food, warmth. My parents did not complain about working sixteen-hour days in their bakery business. How could I complain about anything? They did not complain about anything. Not even the weather.

I believed early on that I had to be strong, responsible and good. I was to consider myself among the most fortunate and blessed of children. I certainly was, and I did surmise, early on, that the best way to survive in my family was to not make demands; not get sick; not complain and just try to be *happy*. There was no room to be anything other than the perfect daughter. I foolishly

With my brother Yonkee

believed that if I did not aggravate them, if I kept to myself, did what was expected of me, they might be a bit happier. With everything they had to worry about, they were not going to have to worry about me.

There are many scientific studies, completed over the past twenty years, that have provided more concise information on the psychological make up of Holocaust survivors' children. I can really only speak for myself and my family. I know that my brother, Jack (Yonkee) Deutsch, has his issues, as I have mine. We have tried to survive having Holocaust survivor parents.

"Self Portrait," ink drawing, 1978, 10" x 6" Collection of Jessica W. Courtney

Words

Can you imagine
how much has
to happen
for one single word
to form?

To say a single
Word.
One single
Word.

First
the
heart has to beat.

I heard someone say:
"one has to know
what must be said –
when it must be said –
and to whom."

That's a lot of words.
and why can we say
some to some
and not to
others?

I speak from
the heart.
I don't know
from else to speak

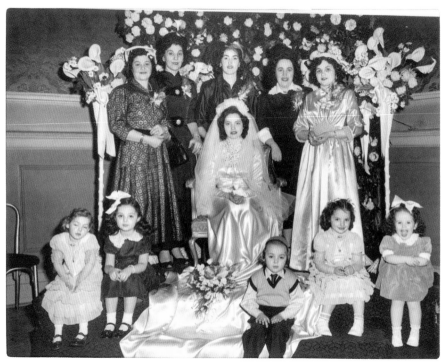

Standing, left to right: Eydu Deutsch Waldman; Lili Deutsch; Chaya Deutsch; Rivka Deutsch; Rici Deutsch Spierer. Seated: the bride, Hindy Deutsch Myzlik. Front row, my first cousins, left to right: Pereleh; me; Yaakov Leib; Tzipi; and Sarah Mindle.

TANTE HINDY'S WEDDING IN BROOKLYN

Some things are simply beyond language. There is not a word I can add to this photograph. I can only speak of what it is; the rest stands beyond the written word.

All these six women, my mother and my aunts, survived Auschwitz together. The five children, including myself, are first cousins. We were all born in Bergen-Belsen. We remain close.

This photograph was taken six years after Auschwitz. The dresses and hats and flowers… the belief in beauty survived. The will to live with beauty remained steadfast. My mother and my aunts brought the past with them to the present. The past they felt was beautiful.

Elie Wiesel, 1985

GROUND BREAKING WITH ELIE WIESEL

In the 1970s, before there were Holocaust museums and the wealth of books and films on the Holocaust that we have today, I had written to my cousin, Elie Wiesel. I wrote a long letter which I sent to Boston University where he was teaching. The desire to use my father's Auschwitz number, A3146, in my work, became more compelling daily. I wrote to Elie for guidance – I questioned the use of my father's number in my work, as I did not want, somehow, to desecrate, commercialize or disrespect the history of the Holocaust. Elie answered, "It was time. Do your work."

For one year, working in a cold studio, in an old run-down

Pages 64–65: "Barbed Souls," 1979, oil on canvas, 60 x 40 in
Collection of Linda and David Altshuler

First United States Holocaust Memorial Museum Council Meeting

Washington, D.C. building, on 8th Street NW, I wrote my father's number on endless amounts of work. I started by writing directly on the paper or canvas I planned to work with, before I actually started painting. I wrote my father's number as well as the stories he had told me: stories of loss and stories of survival. After one year of work, I was left with thirty-six works which expressed, as fully as I could, the search for light in my work, while revisiting this tragic history. The response to the dark paintings, with bits of light breaking through, were exhibited at Jack Rasmussen's gallery in Washington, D.C., in 1980. Jack, a young art dealer, all of twenty-

eight at the time, said, "These dark paintings might not sell, but I am showing them. They are important works."

January 7, 1980, the night of my thirty-third birthday, the Paintings of the Holocaust were shown to the public. The response of art patrons, collectors, art critics and museum curators was beyond what I could have imagined. The paintings were acquired by Jews and non-Jews alike.

Several months after the exhibition, I was contacted by Susan Goodman, the then Chief Curator of 20th Century Painting at the Jewish Museum in New York. Ms. Goodman invited me to exhibit eleven "A3146" paintings in an exhibition to be held at the museum entitled "Contemporary American Jewish Artists." I received glowing reviews by Grace Glueck in *The New York Times* and Paul Richard at *The Washington Post*, in response to this work. Elie was right: "Paint from your heart and you will be OK." Elie Wiesel would write, inquiring how the work was going; he would attend gallery openings of my work, and Elie stayed a strong supporter of my voice, for which I will forever be grateful.

Jewish Museum exhibition, New York

In 1978–79, President

Mindy Weisel

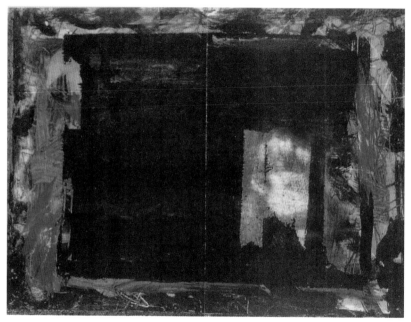

"Ovens," 1979, Permanent collection of Yad Vashem, Israel

Jimmy Carter and Congress agreed to the establishment of the United States Holocaust Memorial Museum. Elie Wiesel, the founding chairman of the establishment of the museum, invited me to participate in the very first museum council meetings. The amount of history to be sifted through, in which to honor the dead, and educate the public, felt monumental and insurmountable.

On October 16, 1985, Elie Wiesel invited me to accompany him to the groundbreaking of the United States Holocaust Memorial Museum. Sitting together, tears streaming down our faces, we watched as soil brought from Bergen-Belsen was being spooned into the ground.

"Lili, Let's Dance – For Lili IV," pulp, painting on artist-made paper, 40 x 30 in
Collection of Vera and Bob Loeffler

LILI, LET'S DANCE

My mother died of lymphoma in 1994. It was unbearable watching my mother suffer. My mother died on January 5 – in between my brother's birthday, January 2, and mine, January 7.

One morning, visiting my mother in the hospital, we talked about dying. I asked if she was afraid to die. "No," my mother said, "I am not afraid. It's just I would like to live." She died two weeks later. My mother, who had survived a double mastectomy, giving birth to a stillborn child, surviving a horrific house fire, and surviving Auschwitz – my mother could survive anything. How is it she is gone?

During the last week of my mother's life, her oncologist came into her room and greeted her with, "Lili, let's dance!" My mother lit up,

always enjoying the attention of men, even in her final days. Her hospital room sprayed with her fragrant White Shoulders cologne and fresh roses from her garden – even dying she was elegant.

The doctor's "Lili, let's dance" greeting kept playing over and over again in my head. My heart took hold and I could hear nothing else but those three words. I kept visualizing how my mother had beamed.

As complicated as my relationship with my mother was, I loved her with the deepest love and often felt I was living just to make her happy. Now that she was gone, I not only questioned what life would be like, I wondered how and if my mother would appear in my work. My mother had inspired endless works over the course of forty years of painting: Lili in Blue; Lili Always. Letters to my mother in paint: painting her pain, as well as mine. Painting her love of beauty, as well as mine. We were enmeshed. I remember the time, vividly, of working on the painting *Winter's White Shoulders*, playing Hungarian music and spraying the studio with her White Shoulders cologne, filling the air with the jasmine fragrance that will always be my mother.

Three months after my mother died, I went to Los Angeles from Washington, D.C., where we lived, to sort out my mother's wardrobe. She had such beautiful things. She believed in having the *finest*. There were closets to go through filled with clothes, shoes, scarves, jackets, hats… most of which I gave away to charity. I kept

some beautiful silk scarves and fine leather gloves, I imagined I would give my daughters. I kept a small handbag I loved. And there were three dresses I could not part with. Three dresses that were her "travel dresses." Her most comfortable, stylish dresses she would wear on her twice a year trips to Washington, D.C., from the West Coast. I could not give these dresses away. I held them and felt a great deep unrelenting sadness.

Three dresses. I felt this overwhelming restlessness that there was something I wanted to do with them. I felt the restless agitation that always seems to rise when I have been away from painting for too long a time.

I took the three dresses back home to Washington, D.C. For days on end, after many "ideas" as to what I imagined I could do with these dresses, I did nothing. None felt "right." One day, I was hit with an idea I wasn't sure could even be created.

I wondered if the threads of my mother's dresses could be made into handmade paper! It seemed such a crazy idea, yet I felt it was worth exploring as paper was made out of many things: wood, papyrus, leaves, whatever could be ground down into wet paper pulp, could make paper. Why not take my mother's dresses and have them ground down into making handmade paper? I went to Pyramid Atlantic and, under the guidance of the artist Helen Frederick, learned that I could grind my mother's dresses down, then work with these papers in which the threads of my mother's clothes

would stay visible. I was also able to incorporate bits and pieces of the fabric into the wet paper, and started work.

The series in honor of my mother was called, "Lili, Let's Dance." Each piece had the initials LDLD bordering the work: Lili Deutsch Let's Dance. I worked with great joy as the work became more and more colorful and, unexpectedly, I never wept. As the time came to sign each work, knowing my heart said all it had to, it was only then that I broke down and wept. Each work became a "For Lili."

While working I felt I was in another world. Lost in the threads, colors and textures of the paper, I felt an excitement in the use of this "new material" and felt inspired by a great love. I was suffused with the happiest of memories. My mother and I sharing moments of awe and wonder at the beauty of the world. While working, I would find abstract roses in the paper; patterns of a life we shared in appreciation of beauty.

I lived for my mother my entire life and loved her deeply. I admired her; I feared her; I laughed with her like with no one else; I respected her efforts in creating a new life; I valued her sense of beauty; I treasured her generosity. There was nothing black and white about my relationship with my mother. I, her only daughter, felt I lived only for her, first and foremost. How is it then, that I felt such exhilaration and freedom at the moment of her death? I worried about losing my mother my entire life. How was it that I experienced a tremendous relief, when she did die? The day of

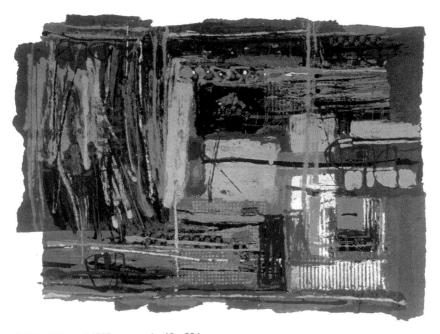

"Lili, Let's Dance," 1995, paper pulp, 60 x 80 in
Collection of Maxine Isaacs

her funeral, I discussed these strange feelings of "lightness" with my mother's rabbi, asking, "Is this in any way normal?" The rabbi said these were feelings of relief. That I had carried my mother's heartache and now that her pain was over, so was mine. I am not sure this was the whole truth. I am sure this was definitely a big part of it, but not all of it.

Lili Deutsch in her favorite color to wear: cobalt blue. 1960.
My favorite color to paint with – always.

The level of anxiety I lived with during my mother's lifetime was immeasurable. I had to be everything in the world to her: I had to play the role of her mother, her sisters, her friend, her confidante, her success, her everything. How could any child carry such a burden? Perhaps, I imagined that I would have a life, after her death, that was not as "driven," not as full of anxiety. I would no longer have to live making another's life, another's survival, worthwhile. Only later did I realize how foolish and temporary the exhilaration I had experienced was. I most certainly knew enough to know that my mother was deeply ingrained in my character, that, dead or alive, I would need to BE all she expected of me. My mother created an overdeveloped sense of responsibility; a longing to make every minute of life "worth it;" a feeling that life needed to be fully fulfilled with meaning. I soon realized that those feelings would never leave me. The feeling that I was raised to give her life value was going to stay a constant.

At my mother's burial, I sat like a stone. I did not shed one tear. At the graveside, I sat near my father, brother and my husband. I watched as my mother was lowered into the ground, and I could not cry. Had I allowed myself any feeling at all, I do not think I could have gotten through it. I knew my grieving would come. And indeed it came, and, when it did, it was overwhelmingly powerful and uncontrollable.



He reappears

You rose from a snowbank
with three heads, all
your hands were in your pockets

I said, haven't
I seen you somewhere before

You pretended you were hungry
I offered you sandwiches and gingerale
but you refused

Your six eyes glowed
red, you shivered cunningly

Can't we
be friends I said;
you didn't answer.

- 12 -

Printed right page:

You take my hand and
I'm suddenly in a bad movie,
it goes on and on and
why am I fascinated

We waltz in slow motion
through an air stale with aphorisms
we meet behind endless potted palms
you climb through the wrong windows

Other people are leaving
but I always stay till the end
I paid my money, I
want to see what happens.

In chance bathtubs I have to
peel you off me
in the form of smoke and melted
celluloid

Have to face it I'm
finally an addict,
the smell of popcorn and worn plush
lingers for weeks

- 13 -

Handwritten left page:

my own 25 year old Carolyn?
I was just in her place. But
these daughters, these glorious
daughters, have the blessing of
not being the "only" daughter —
they have each other; They have
the luxury of complaining;
discussing; appreciating;
sharing their mother. They

Handwritten right page:

feel they have the right to
say to me "Sorry mom, thats your
problem — not mine." I cannot
imagine not only not saying
that sentence but what it
could possibly feel like to ~~the~~
so seperate from my mother.

A letter to My Mother — 1994

A LETTER TO MY MOTHER

Three years after my mother died, I woke up in the middle of the night and simply had to write my mother a letter. It was a cold January night, like the month in which she died. I was warm and half asleep in bed and did not want to leave my warm bed, yet the powerful need to write did not let me fall back to sleep. I turned on the bedside light and saw only the book of poetry by Margaret Atwood, I had been reading before falling asleep. There was no other paper to write on near me, and I just started writing in the margins of the book. I wrote not only in the margins but over Atwood's poetry as well.

The letter reads as follows:

> There is no room left in me for how much I miss
> you. The space that used to be full with worry

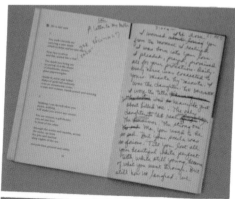

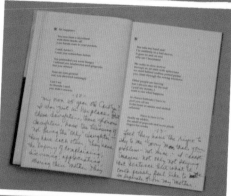

about you, for you, empathizing with all that you had suffered, is now full of longing and grief. My life lived for your every happiness is now filled with the deepest sorrow because you are no longer here. Now it is MY grief I carry, not yours. It is unbearable to me that I shall not see you again. I worried, since a young child, that I'd lose you, the way you lost those you loved.

I had to stop writing at this point. I was flooded with grief. As it is, I was writing in near darkness, as not to wake my husband soundly asleep near me. Flooded with tears, I kept writing:

I walk into a room with a hint of your perfume, "White Shoulders," and I fight back tears. I hear "broken English" spoken with that marvelous Hungarian accent of yours, and I want to embrace whomever is speaking it. I want to go up to every beautiful, elegant European woman and say, "You remind me of my mother." I want to walk into fine linen shops with crisp cotton bedding and tablecloths and say, "My mother loved these things." I tell my three daughters how I miss you. Long for you. How badly I want to call you and hear your voice; your laugh and to tell you about my children that you loved.

I experienced a certain "calm" at this point and started remembering, with a certain clarity, how difficult it was, in reality, having a mother who was damaged by the atrocities of war. I continued writing, not in any way romanticizing my relationship with my mother. It's not that what I had written up to that point wasn't "honest" – it was just not the whole picture. I wrote with a more realistic, truthful, open side to the story.

> I do not forget how troubled you were and how difficult. How truly impossible you could be. Nervous; agitated; anxious; driven; screaming; paranoid. I spent my life trying to keep those feelings of yours at bay.

> You, my mother, used to say, "I don't want 'IT' to die with me." IT: your life; stories; beauty; family; the memory of your parents, your sisters; the generosity in your home. The Jewish life you lived. You painted a clear picture of it all, as if I had actually lived in that time in your house, with grandparents, with aunts and uncles, with the flowers, the crystal, the people that populated your life "before" – before the war. The longing to paint those stories has never left me. Here I am now, with a desire to talk of the AFTER. After you are gone.

You claimed not to believe in religion, yet when you left the house for the hospital, you kissed the mezuzah on your front door. Kissed it because you were hoping this act would keep it from being the last time. You never did walk by that doorpost again. You never returned to the elegant home you created. The home you created out of remnants of your past.

The crystal, chandeliers, glasses, dishes, platters, bowls, decanters. Hungarian crystal. You were the keeper of memories. You collected so you could show me, teach me. What it felt like *"in dehr hym"* (in the home). The embroidered tablecloths, pillowcases, down comforters, hand-sewn duvets, triple brocade drapes, lace, velvet, needlepoints on the walls, on the chairs, the sterling silverware, candlesticks, teapots, Rosenthal.

I stopped writing and with a heavy heart went downstairs to make a cup of tea. Returning to bed, I felt emptied by emotion and felt an empathy for my mother like none I had felt before.

No one will ever really know all that you had to do to survive. You stayed strong inside, and beautiful till the end. Where on earth did you find the strength?

I don't miss your strength as much as I miss your kind, sad, loving and generous heart. Life was difficult. Not only because I felt so alone, but because having to carry your pain became unbearable.

I miss you, my mother. I miss you everywhere. How do I live now when I only knew how to live for you? What does it mean to live just for "one's self"? How can that possibly be enough?

I am tired and will end now. I trust you are watching over us. And I will try to be happy. After all, that is all you wanted: for me to be happy.

NO ROSES ON WEST SEVENTY-EIGHTH

Visiting the cemetery in Los Angeles, at the one year anniversary of my mother's death, her *yahrzeit*, I noticed my mother's tombstone is the first in a new row of tombstones. I memorized her new *address* – her final resting place: her row is West Seventy-Eighth. I realized that the next painting I would work on, dedicated to my mother, would be one she will never see. I left her place, reading the words engraved on her stone: "A thing of beauty is a joy forever" Keats. I thanked my mother for teaching me well.

Pages 94–95: "No Roses on West Seventy-Eighth," 1995, watercolor, 40 x 60 in

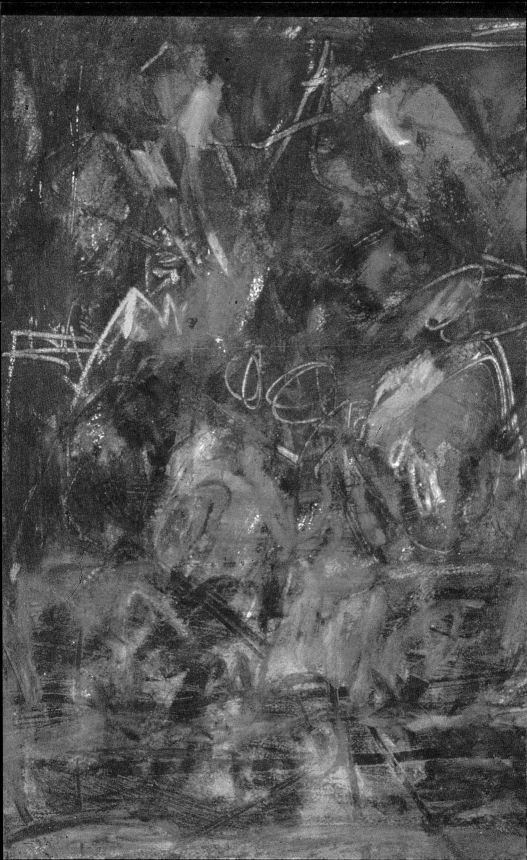

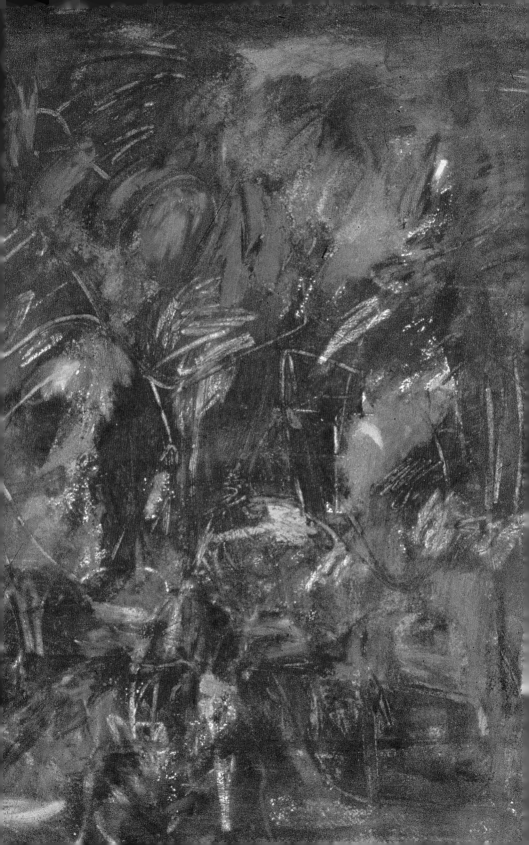

"A work of art is a trace of a magnificent struggle."

– Robert Henri

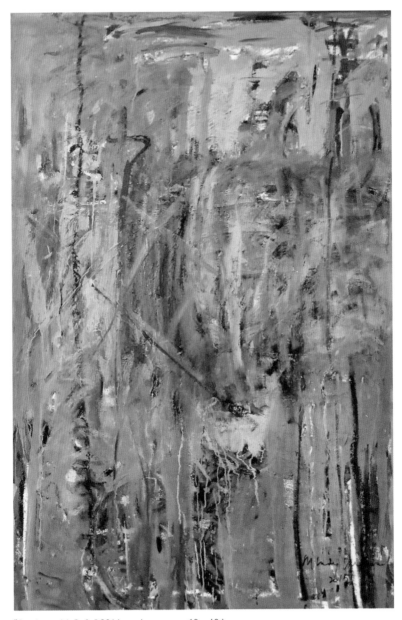

"Sundays with Rafa," 2014, work on paper, 60 x 40 in

Collection of the Phillips family

"September 19, 1987," metal disc, 6 x 7 in

SEPTEMBER 19

In our family, September 19th will never be the same. It is the anniversary of what we call *the incident*.

We had moved into a charming townhouse in Georgetown, on the corner of Q and 29th Street NW. I was thankful to have left the suburbs. The three-story house was very much a work in progress. A year after moving in, we had yet to install door locks on the bedroom doors. This turned out to be quite unfortunate.

On a sunny Saturday September morning, my oldest daughter, Carolyn, was away at a friend's for the weekend and my two youngest daughters, Jessica and Ariane, had gone to synagogue services with my husband. While resting in our bedroom, on the second floor, I suddenly heard footsteps. I thought how strange, they couldn't

be home this early from synagogue… As I got out of bed, dressed only in my white nightgown, a man started running up the stairs, towards me, with a knife. I ran back into the bedroom, but there was no lock to lock the intruder out. He ran right into the bedroom after me.

The man jumped me and had me on my knees at the side of the bed. His knife was held at my neck with one hand, while the other was held tight on my mouth. "If you don't scream, I won't hurt you." I remember trying to move his hand from my mouth, thinking if I could only talk with him. I would offer him anything in the house. The very next thing he said was "get on the bed." As he started to repeat this, I pushed the Dictograph Alarm's panic button, which, miraculously, was right near where I was kneeling. I was not *thinking*, I was on an automatic survival mode. The alarm started raging as soon as I pushed the button. Luckily, instead of the knife going into my neck, the intruder, knife in hand, ran out of the house.

I will forever remember the softest lightest shade of color – of the air – that infused our bedroom after he ran. It felt like a protective light. A soft, soft shade of turquoise. I needed to call someone to go get Shelly and bring him home.

It felt like forever till the police came. After making several calls, I finally got in touch with a friend who went to get Shelly and the girls from synagogue. As soon as they walked in, I started to

shake uncontrollably. The police showed up about the same time, and shortly after a detective arrived. I was repeatedly questioned whether I would agree to a medical exam, as they were not sure I was telling the truth that I was not raped. Thankfully, I was not, yet I kept shaking violently.

For four nights straight, after the incident, I could not sleep. I stood at the window in our bedroom as every tree became the intruder as soon as night fell. The days were no better. I could not be alone during the day for months. Just going into an elevator had me panic stricken. I most certainly could not be alone in my studio.

Within ten weeks, my husband found a beautiful home in Maryland, and we moved back into the suburbs. Step by step, my ability to be alone returned. I was longing to get to my studio, which was still in D.C., yet I found it almost impossible to do so. One day, however, I got to the studio but all I managed was to walk up the stairs and face the front door. I could not go in. Thinking I actually would be able to go to work, I had brought a new tube of deep burgundy paint, as well as materials I knew I needed at the studio, with me. I stood at the door which felt like forever. Facing the door, realizing I simply could not go in, I decided to just paint the door. The door, from floor to ceiling, was painted dark burgundy. I painted the door and went home.

Months later, once I was back in the studio – I was doing short bursts of work and then rushing out. One day, I felt I could stay

Mindy Weisel

"September 19, 1987 (Unusual Knife Handles), The Incident," drawing, 6 x 7 in

94

longer. I took small square sheets of handmade paper, and with pencil, I wrote about the incident. I wrote and started drawing stick figures reenacting the entire episode. I felt distant while working, yet got it all down.

I was teaching at the Corcoran College of Art and Design during this time in my life. A student, in my class, studying abstract painting, was also in another class at the Corcoran, where she was learning how to make objects. She chose boxes. These boxes were exquisite: covered in beautiful fabrics and in interesting shapes. I asked her to meet after class one day, and told her about the incident. I asked her if she would be so kind as to make a box for me to house – (more like bury) – the writing and drawing pages. I offered to compensate her for materials and her work – she refused to accept. This beautiful box in which I buried an almost tragic tale, is one of the most meaningful gifts I had ever been given. Art closed the ordeal once and for all. Like an urn, its ashes remain on a shelf in my studio today.

P.S. Like details at the end of a movie: they caught the intruder – he had left knives in the kitchen and front door when he ran out of the house. I was spared having to identify him in a line up. The detective, kindly, brought me a photo of his line up. There was no missing him. There he was. I heard he was to be incarcerated for one year.

"Sleep"

"Crash"

"Footsteps"

"The Run Up"

"Caught"

"Scream"

"No Feeling"

"At the White Bed"

"Pleading"

"Knife Point"

"The White Bed – With his Blood"

"The Alarm Button: Near the Bed"

"The Freeze"

"The Run"

"The Miracle"

"Shaking"

"Dictograph Calls"

"I Make Calls"

"Alone-After"

"Not My Call"

"Caution – Scene of A Crime"

"The Bigger Knife"

"Goymil Bentshing"

"Nightwatch"

"Kitchen Bars"

"The Story Ends"

28 Dec 1987 /

Today is the 1ˢᵗ day back at work where I can lose myself into making something other than hearing every sound. Ninety days ago life really did change. And I know fear. I would like to do this book (of all these samples of paper) as a record of what I have been through & where the energy had gone during this time. I am back.

Today is the first day back...

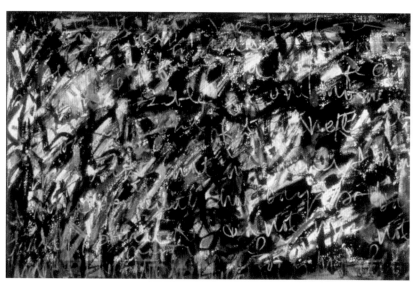

"Who is the Driver?" 1996, work on paper, 22 x 30 in Collection of Sheldon Weisel

DOCTOR, TELL ME

I called my father recently, wondering how he and my mother had let me travel the subways alone when I started first grade. After school, I had to get from Brooklyn to my parents' bakery business in Bensonhurst alone. Weren't they afraid I'd get lost – kidnapped – hurt? "What would they do if I didn't show up?" was my daily thought as I sat, afraid I would miss the stop to get off. The doors opened and shut so quickly on the subway, it became a daily trauma. I lost my homework, my eyeglasses, my school bag. And I did miss stops. I asked a stranger once for a token. Even the day I got hit by a bike while exiting the subway station, I remember simply walking into the bakery. I didn't cry or complain and was just friendly to the sales girls, as was expected of me. My parents were always busy. I took the broken cookies they couldn't sell that

day and sat, ate and waited. My father's answer to this question of how they could let me do this alone at such a young age was, "Mindeleh, don't be silly… you were grown up already when you were a year and a half old in Bergen-Belsen. You were independent already then. You walked around, sat on a thousand people's laps who had just survived the camps, like your mother and I. We never knew where you were. You were already grown up by then. By six you were an adult."

Can you picture the people whose laps I sat on? Their eyes mirrored back a love filled with grief, a dead numbness. One thing is certain: they did not mirror back security; safety; protection. I opened my eyes at birth looking into a thousand black mirrors. The first one, of course, the black mirrors of my mother's eyes.

When someone asks a simple question like, "How are you?" I wonder how can one possibly answer that. It not only depends on the day but the minute. How can so many different emotions rule a life?

Exhausted. What does that word even mean? How can I be exhausted? I'm not working sixteen hours a day in a bakery as my parents had. I am not an immigrant nor a Holocaust survivor. I did not have to create a new life from sheer and total darkness. Yet, I feel I am never doing enough. Enough of what? Making my birth worth it?

With great heartache, I remember a quiet conversation I had with my mother a few weeks before she died. She had just learned that morning that there was more metastasis. My mother looked at me, while **one** tear fell – just one tear – and said, "Mindeleh, I guess I still have to pay…"

As I left the hospital I wondered, how could this woman, who had been through many hells, still feel accountable that day in the hospital? How could she feel she still had to "pay" for surviving? She witnessed the loss of her four sisters and their young children; three brothers and their families and her parents. She was the only woman who survived.

There was not a scent that escaped my mother. My mother would announce a smell! Is it a wonder? How did she ever get the smell of burnt corpses out of her hair? How did she get the smell of shit and urine off her skin? How? How did my mother manage to live? And wasn't it my job, her only daughter, to make life as beautiful for her as I could? So – doctor, tell me – maybe I really am not confusing depression with fatigue. Maybe, in fact, I am depressed AND exhausted.

My children ask me how I am. I say, "spent." They say, "rest." I think to myself, I wish I knew how.

I have had many doctors suggest I confuse fatigue with depression. I am not depressed they say – I am exhausted. *Being tired* was

A new life: visiting L.A. with my father and Dita Sidlow Deutsch, 2000

not an option growing up. Workaholic parents doing a hundred miles an hour, while standing still, are hardly a stellar example of repose. I am not sure why I am still surprised at my exhaustion. It catches me by surprise over and over and knocks me to the ground, leaving me with no air to breathe. The tank empties as I do not know how to read the gage. I have collapsed more times than I care to admit.

The collapses can be charted and are probably predictable. Yet, I cannot listen to reason. To be driven is just that: to be driven. One of my favorite works is a painting – a watercolor and oil pastel on paper done in 1996 called, "Who Is The Driver?" I can still feel the agitation in which I worked – not writing nor painting quickly enough. Driven by an emotionality I never will understand. Painting was and is a safe place in which to express emotion. Alone in the studio I am free to express whatever it is that demands expression. On white sheets of paper or white yards of canvas I am the star of my dramas. My theater of a life. I am not tired while working. I am not tired when I am actively "doing" anything, whether mothering a child; completing a major body of work; preparing for an exhibition or traveling. I am the most reliable when needed. I only fall apart **after**. After. I am perfectly capable and strong in the moment. I work fast and thoroughly. I do

not disappoint. I do not run late. Everything is done as promised and as beautifully as possible.

The fatigue comes from a fear that I am not doing enough with my life. Anyone paying attention to me as a kid might have predicted this life. Look at the books I read at an early age. Camus; Kafka; Genet; Beckett; Sartre. At fifteen I wrote a paper on Nietzsche. My adolescence was Camus' *Myth of Sisyphus* and by the time I was married, at eighteen, I felt I was in a Beckett play, waiting for meaning to present itself with Sartre's impatience.

I tell my doctor at one of our last sessions that I wish I had inherited my father's ability to move forward in life with the self-sufficiency he has, as well as his strong defences. He was heart-broken when my mother died, he spent the entire month at her side, in the hospital, day and night, as she was dying. Yet, a year later, he was able to remarry and yet again start a new life. He married Dita Sidlow and they started an interesting life together.

Mindy Weisel

Virginia Center for the Creative Arts retreat

TOUCHING QUIET

The summer of 1992, I was awarded a one-month painting fellowship at the Virginia Center for the Creative Arts, a two-hour drive outside Washington, D.C. This fellowship meant a month in which to work without life being wrapped around a myriad of other responsibilities. It was challenging being a painter, living in Washington, D.C., married to a hard-working Washington attorney and raising three daughters, each born five years apart, and trying to mother. I was growing as a painter. The overdeveloped sense of responsibility I felt, since a young child, started to butt heads with the ever-growing conflict between family and making art. The desire and demands of our family grew at the same rate, it seemed, as the need to be alone in my studio.

I rarely had three hours a day to paint. Setting up, cleaning up – all took time and energy. In the mornings, I would drop my daughters off at different schools, rush to the studio, paint intensely, close up and rush back to pick them up. The need to be present for my children was paramount.

In the hours I was free to work, I felt a sense of fulfillment that I did not experience in any other area of my life. While painting, life made sense. I was freed from the gnawing feelings of free-floating anxiety, as well as a vulnerability that seemed to be with me when I was not working. Painting, writing, reading – alone time in the studio – gave my life meaning outside the "normal" fulfillment of family.

The summer of the VCCA Fellowship was time, space and beauty opening up. When we arrived at the artist residency, I was stunned by the breathtaking beauty of the landscape. Six hundred acres of green and every shade of summer flower imaginable. It was beyond language beautiful. Yet, as I looked around, seeing only acres of farmland, cows at the gate, and not a coffee shop in sight. I had an instant panic attack: what will I do here for a month!?

After setting up the spacious studio with my husband's help, he drove off to our home in Washington, D.C. I felt like a kid being left at sleep away camp. I felt lonely, anxious, and worried whether I could and would make the most of this one month of freedom to

work. The expectations I put on myself are enormous and I am my strongest critic.

That evening, I saw a snake near the front entrance of the artists' residence hall as I was walking toward my room. As I was settling into my small, simple room, with the shared shower, I could not shake the image of the snake. I missed home and I felt homesick.

The next morning, in the large, light-filled studio, I started a painting in which I drew a snake. The first painting, the morning of the Fellowship, became "Of Snakes and Partings." The snake painting done, I took a long walk in the green lush fields. It was so damn quiet. I was very anxious while walking, worried how I would get through the month. The other Fellows, from all over the world – writers, poets, composers, sculptors – that I had briefly met at breakfast, were nowhere to be seen. There was not one person out while I was on my walk. As I walked, I found my heart and mind surrendering to the exquisite beauty of the Virginia countryside. While walking, looking up at the cloudless sky, in the total quiet, I realized what I would paint for the month: quiet. I would paint the quiet. What does quiet feel like, look like? I would explore this experience of being IN this quiet, as fully as I could.

The very next day, I started work on a painting called "Touching Quiet." I also began writing in a journal that I kept the entire month I worked. Every morning, before starting work, I chose

music, started painting, and I would write in my journal at day's end. The painting and the writing became a daily response to the quiet I was experiencing. I approached each day the way you would a new relationship: some days the quiet felt sublime, while other times, less than exquisite. There were times when the quiet was excruciating, as in the days I worked on the painting "A Storm of Solitude." Engulfed by absolute stillness, the work became more and more layered, more and more mysterious, deeper and darker. I seemed to stay in a state of high anxiety while working. It became clear that this particular painting was demanding emotions I usually try to run from. Perhaps I finally had felt safe enough, at VCCA, to feel as deeply as the work demanded. There was no escaping the place or the feelings.

My appreciation for quiet had been hard earned. For most of my life, I ran from it. Being *quiet* meant "being" with my feelings. There was too much anxiety, restlessness, fear, to allow myself quiet. How IS one quiet anyway, I wondered? All I knew, up to that summer, was an all-encompassing hurriedness. I spoke fast, moved fast, kept running, worked and stayed anxious. I felt I had to be vigilant always – not only to ward off the feelings of impending doom that always seem to be with me, but also to make sure that my life felt *worthy*.

My parents worked long hours in their bakery business, six days a week. Their idea of "enjoyment" was a bowl of fresh fruit, a bit of the news on TV, and that was it. My father was up at three

a.m. each morning to open the bakery. My mother went off as soon as we left for school. My parents were always in a hurry. I hardly ever saw them sit down. I learned, by example, to do things quickly, efficiently and with the same impatience they exhibited. I expected each day to be productive. During this time of painting, I realized my constant agitation, busying myself with one thing or another, or one drama after another, had all

Mindy and Shel Weisel, 1992

been a manifestation of the inherited chaos of past voices. I was starting to understand that there were different ways of living than the "rush" I was raised in.

I seemed to understand that the only place to *run* was into the work itself. The sole demand I placed on myself, during this time, was to experience the quiet as honestly and openly as I could. I needed to feel it; write it; paint it; learn from it.

There was a heat-wave the July I was in Virginia, yet, I seemed oblivious to it. I worked long hours. I was living an interior life where the freedom to work was exhilarating. I experienced a full range of emotions, a full range of reactions, to the quiet I was living in. Day in and day out, in that enormous white washed studio, with the paint-stained floors, I responded only to what the quiet was evoking.

I started painting early in the cooler morning and I worked well into the evening. I felt in harmony with my work, and the work seemed to flow. The work, full of color and emotion, reflected the relationship I was having: just the quiet and me. Solitude. Glorious solitude.

At the end of the month, I came home with twenty-eight newly completed works. I was grateful and totally spent.

One year later, I was invited to exhibit the "Touching Quiet" work in Washington, D.C., at the Jones Troyer Gallery. The reaction to the series was stunning. All of the twenty-eight works were acquired at the opening. It was very exciting, rewarding and fulfilling.

The exhibition, however, was held during a difficult time in my life. It was during the time my mother was dying. It was an intense emotional time. I was thrilled and grateful that my mother lived to see the response to this work. It was the last exhibition of mine she lived to see.

A year later, the publisher Kathleen Hughes, who had seen the exhibition "Touching Quiet," contacted me, asking if I had kept any writings while working on this series of paintings. Kathleen read the journal I had kept during the Fellowship at VCCA and decided she would like to publish it. The book, *Touching Quiet: Reflections in Solitude*, resonated with so many who expressed a desire for quiet and solitude in their own lives.

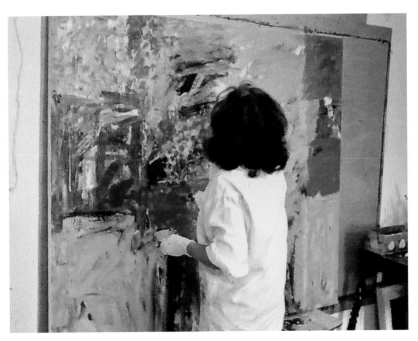

Working on "Meditations on Love," 2015

Amazement

The souls of the dead
stand in amazement
first and foremost.

They
the witnesses to
life's fleetingness
speak
through angels.

We only have to see
them.
or do we hear them?

They wonder
at our seriousness
our worry.
They whisper
enjoy enjoy.

My belief in moving forward with love is unshakeable. Despite all the atrocities committed by the Nazis, atrocities that impacted my life profoundly, I simply do not believe in hate. As much as I was raised with a great sadness – a defenseless sadness that is a permanent stain on my heart – I believe the only antidote to hate is in expressing love for mankind. I believe in kindness and in creating beauty. We must not stand by passively nor allow hatred to undermine the love we need if we are to live in a civilized world. We must, of course, resist those people who believe that our differences give them license to lash out. We must not forget the essential message now, as always: only love and a passionate move towards action for the good can enrich our world.

– Excerpt from a talk I had given at Oxford University, January, 2020. 75th International Holocaust Remembrance Day.

Speaking at the U.S. Embassy in Berlin 2009

BERLIN

You choose — we can go wherever you would like. My husband and I were trying to decide where to travel for an upcoming birthday. At first, I thought Hungary. I always cared to see the elegance and beauty my mother spoke of. I decided on Berlin.

I had been to Germany only once before — in the 1980's for an art fair — Documenta — held in Kassel. On the way to Kassel, I stopped in Frankfurt, for a day, to see the contemporary architecture and Decorative Arts Museum designed by the architect Richard Meier. A day in Frankfurt was the only city I had visited in Germany. Kassel was a world of lush and green forests.

Berlin. The architecture; museums; Holocaust memorials; cafes and apple strudel! A close friend of mine, also a Holocaust survivor's

daughter, went every year to the Berlin Film Festival, and she would describe Berlin vividly. It sounded like a fascinating city.

While planning our trip to Berlin, we were contacted by the U.S. State Department's Cultural Affairs office. We were told that the U.S. Embassy in Berlin hoped to host a dinner for us during our stay. We planned our itinerary around the date they gave us for the dinner, which was my birthday, January 7th.

Fast forward from January 7, 1947, Bergen-Belsen to Germany January 7, 2007, the Savoy Hotel. The elegant Savoy Hotel was where the dinner was held. We had no idea what to expect. All we knew is that we were going to meet people from the U.S. Cultural Affairs office. When we were ushered into the luxurious dining room, tables were set with fresh red roses on crisp white linens, people were already seated.

As we were being introduced to the other guests, the crystal wine glasses were being filled with champagne. There were twelve people at the dinner. It was, as they said it would be, "a private affair." Writers and artists, members of the United States Embassy in Berlin, as well as an elegant, lively German woman, also an artist, were friendly and welcoming. The conversation and the food were wonderful. At dinner's end, the lights were dimmed and a chocolate birthday cake, a linzer torte, was brought out on a tray of

red roses, candles lit, and everyone went into song. Happy Birthday. All I could think of was, *If you live long enough…*

Berlin was as fascinating as I imagined. The old ornate buildings edge to edge with the clean modern lines of the new; the art museums along Berlin's Museum Island, especially the Pergamon Museum, were monumental. We spent days visiting the museums, walking the different neighborhoods, having strudel, and deciding to go to the Holocaust Memorial only on our last day of the trip. I felt I wanted to enjoy the time and I longed to stay present for as long as I could.

During our stay, we were introduced to a few German artists and others we met while having coffee or a drink. I could not help wondering, when we were talking with Germans, where their parents, grandparents, uncles or brothers were during the war. If I felt particularly comfortable, I would inquire, openly and directly, about their personal history. Each German had their own story: some families who were anti-Nazi, during the war, spoke of their family members who were imprisoned and murdered; others spoke of their families hiding Jews during the war. One young man told us he was studying Hebrew and was involved in an organization of cultural events shared between Israel and Germany. Many stories. Many Germans. *This is the danger of generalizing… of stereotyping.*

On a particularly warm, clear day, while in Berlin, I suggested we go "antiquing". I enjoy looking at antique jewelry when traveling. We came across a charming shop with a handsome red bracelet in

the window that caught my attention. I loved it, and just as I was ready to buy it, I had a slight panic attack. I pulled at my husband's jacket sleeve and whispered that we had to go. I had to leave. How did I think I could buy a piece of jewelry in Germany? How would I ever know where it came from: a Jewish home that had been confiscated by the Nazis or a German home that had been Nazis? Buying anything old in Berlin, I realized, was an impossibility.

The last day of our trip we visited the Holocaust Memorials. What surprised us was that these memorials were centered in one of the chicest neighborhoods, most expensive real estate, in Berlin. There is no question, among the Eastern European nations, Germany expresses the greatest remorse over the tragic history of WWII. Germany has allotted a great measure of funding in the design and building of great monuments in memorializing the six million Jews murdered during the Holocaust. I was unusually moved at the Holocaust Memorial in Berlin. We walked among the rows and rows of what look like gray cement coffins, which led to an interior museum. I started to weep as soon as we walked in… we were walking on a glass floor, under which thousands of letters were visible. It was an incredible installation. Old letters. Letters and letters. These letters were found after the war: thrown from trains; found in concentration camps; discovered under rubble as new buildings were being built. I felt the most vulnerable and defenseless I had ever felt in any Holocaust museum. I felt almost paralyzed with grief. Letters…

Later that afternoon, our tour guide pointed out the brass plates, *the stepping stones*, embedded in the sidewalks, in front of homes where Jews were rounded up by the Nazis. We visited the Berlin Jewish Museum and found the Daniel Libeskind architecture powerful. I started to feel emotionally depleted and longed to return to the hotel.

By the time we left Berlin, we had walked the streets of Mitte, Kreuzberg, Prenzlauer Berg and Friedrichshain. We had visited segments of what was once the Berlin Wall; Checkpoint Charlie; Brandenburg Gate and the United States Embassy in Berlin, which houses a significant contemporary art collection by American artists. We had drinks at the famous Adlon Hotel; strudel at the best cafes and visited the contemporary art galleries. A magnificent exhibition by the Swedish artist Per Kirkeby, whose work I love, was up at the Werner Gallery and I was thrilled. A great cosmopolitan trip. I wondered why I did not feel *guilt* not only being in Germany, but actually enjoying it. I know that other survivors' children's friends of mine would not travel to Germany nor would they ever buy a German product. How is it I enjoyed this trip immensely?

Once home, I called my father, described the trip, and asked him if he felt it strange that I enjoyed Germany as much as I had. "Mindeleh, you were not raised with hatred. We live in a new modern world: enjoy it." I hung up the phone and cried. Then I went to the glass-making studio and did a work in glass called "Stepping Stones."

The mayor of Dachau - welcoming me - 2009 - Germany

DACHAU IS CLOSED ON MONDAYS

The U.S. State Department Cultural Affairs office called to finalize the itinerary for a three-week trip planed to Germany, where I was to serve as a Cultural Emissary in Berlin, Hamburg, University of Kiel, and I was scheduled to speak at the German Foreign Affairs office, as well. I was going to Germany as an American artist, and Holocaust survivors' daughter, representing the United States on a Cultural mission.

While the U.S. State Department was organizing the schedule with the German office of Cultural Affairs, I received a call from a scheduler at the U.S. Travel office saying that Dachau is usually closed on Mondays, yet, they were just informed they will keep Dachau open for my visit, scheduled on a Monday. When we hung up, I felt slightly dizzy – I was afraid I would faint. When my

husband asked how the call went, all I could say, over and over again, "Do you believe this sentence: *Dachau is closed on Mondays, but we will have it open for your visit.*" The entire phone call had set my heart and head spinning. I was going to visit Dachau, where my mother had been before Auschwitz. *Will I be able to handle all this?*

Dachau was my "first stop" during this German mission. The visit, however, did not start at what once was the concentration camp, as I imagined. We stopped first in the town of Dachau – a charming village. Colorful buildings, charming cafes and shops. Accompanied by the U.S. Cultural Affairs staff, and a dear friend of mine, Phyllis Greenberger, who had accompanied me to Germany, as well as Martin Lorch, the German gallerist who was hosting an exhibition of my work in Berlin.

As soon as we got to Dachau, I was greeted by the Mayor, waiting for us at the entrance of a lovely cafe. He welcomed me warmly. As he was speaking, I was having an out-of-body experience, and do not remember one single word he had said. After a few pleasantries, we said our "Auf Wiedersehens." We were ushered into a light-filled restaurant where we were to be luncheon guests of four German artists. The four artists' fathers had been affiliated with the Nazi party during the Holocaust. I later learned these artists stayed in Dachau, where they grew up, as guardians of a history hoping not to repeat itself.

The dining room: a cheerful yellow, suffused with light, with a long table set with light blue linens and six cobalt blue memorial

Bruno, a Nazi's son, reading me a letter of apology, Dachau 2009

candles in a silver candelabra that were already lit. The candles were a visual commemoration in honor of the six million Jews who were killed in Nazi Germany. Flowers and beautiful breads were set at every place setting. We were literally going to *break bread*.

Before our meal was served, we were welcomed with fine German wine. While I was starting to relax, Bruno, one of the artists, whose father was a Nazi official, clicked his crystal glass and stood up to speak. He was holding a sheet of paper in his hand, and, as he looked down at it to start speaking, he started to weep quietly. It took a minute for him to collect himself, and he then read a

meaningful, heartfelt letter of apology to my family. A translator was translating the German into English as he spoke.

He cried. I did not. I kept thinking, *if my mother could see me now.* Fresh roses, no less, on the table.

The four German artists were gentle, soft-spoken individuals. Through the interpreter we exchanged information about our art, and our personal histories. They with their guilt, me with my sadness.

After lunch, Bruno accompanied our group to visit what once was the Dachau Concentration Camp. The Arts 21 film crew were already there, expecting our arrival. It was all of 2.2 kilometers (a little over 1 mile) from the town to the camp. I found this remarkable... the town being in such close proximity to the camp! What did the residents of the town think, seventy years ago, when truckloads of people were driven through their town and were never brought back?

I was given a tour of the Dachau Concentration Camp. My mother used to tell me stories of how four women would sleep on a wood board and all would have to turn, at night, at the same time. They slept like sardines. As I was viewing the bunkers full of wood boards that served as beds, I asked the museum guard, rhetorically, while holding back tears... *what did the carpenters think they were building?* Exiting the bunkers, we came to a long, clean corridor, with forty-eight toilets lined up – no seat – no lid – just a hole of a

Dachau 2009 - At Educational Center - After speaking to
High Schoolers (some whose grandparents were Nazis) who
presented me with a bouquet and wanted their picture taken

toilet. Forty-eight brown toilets lined up in perfect order. Flooded
by a sudden silence, I could not speak. All I could think about
was how did my mother, my elegant, beautiful mother, survive this
inhumanity. I was told that all the prisoners had to "go" at the same
time. There were toilet shifts. I notice that Martin, the German
gallerist, was weeping.

At the Dachau Educational Center, the stop after the concentration
camp visit, there were over one hundred young teenagers sitting
quietly, ready to hear the guest speaker. I was introduced in
German and English, and spoke to them as lovingly as I could. I
felt an unconditional kindness towards these kids. What were these

Professors from the University of Kiel
attending my lecture, 2009

Announcement of my lecture, "Art as
Autobiography," given at the University of
Kiel, in a burnt out bunker, now a lecture
hall at the university, 2009

young German children to be blamed for? Nothing. They were at the Educational Center to learn about what *happened*. While I spoke, images of my paintings were being shown on a screen behind me. I spoke of the *survival of beauty* and the obligation we all have to create a world of peace and harmony. I encouraged the young people, who were listening very attentively, to enjoy and pay attention to flowers. At that point, a young woman came up to the podium and presented me with a lovely bouquet of fall flowers in burnt oranges and reds.

During questions and answers, a teenager stood up, the only one brave enough to do so, and asked, in excellent English, "How does our generation make sure this never happens again?" I answered as best I could and left.

All in all, I felt grateful and fulfilled by the time spent in Germany. I met each day with openness and warmth, more convinced daily that the need to emphasize the *survival of beauty* might well be a means to face the future.

Dachau artists

The night before I was supposed to leave Germany, after giving a lecture in Hamburg, a lovely young woman introduced herself as the curator of the Bergen-Belsen Museum and invited me to visit Bergen-Belsen the next morning. It was closer to Hamburg than I would have ever imagined. Bergen-Belsen, now a museum with acres of serene green fields with a modern structure housing documents, photographs, a record of a tragic time, was not a place one would have ever imagined was a concentration camp nor displaced persons camp.

The director of the museum, holding a long wooden stick he used as a pointer, showed me a wall with photos of the hospital grounds, of where I was born, and where the barracks we lived in were located. While he was speaking, the curator I had met the previous night, said she had a surprise for me. She brought out copies of my birth certificate, my parents' identification papers, and when I saw my mother's unique handwriting, her signature on my birth certificate, I could no longer hold back the tears I held at bay for all my life.

Sehr verehrte, liebe Mindy Weisel,

Danke für Ihr Kommen,
Danke für Ihr Interesse an Dachau
für Ihr Interesse was Dachauer Künstler so machen ...
hier Christine Sattler Niklaus Heibudi, Dieter Nau
Für Ihr Motto »**Ich komme völlig ohne Groll ...**«
bewundere ich Sie.
Für Ihre **Kraft, ihre Größe** ... _für Ihre künstlerisch Arbeit_

Das hat mich stark bewegt und beschäftigt.
Was ist **Groll, Wut, » heiliger« Zorn** ...
Was darf, was **muß** ich davon haben, **wann, wem** gegenüber.
Anders als Sie es meinen ... kann es für mich Antrieb sein ?

Meine **Verantwortung** gegenüber unserer Geschichte sagt mir
-- **sei aufmerksam**, sei **hellhörig, misch dich ein** –
wenn sich das **Wort**, die **Tat** gegen den **neben mir stehenden,**
gegen den Nachbarn richtet.

Ich hoffe, ich will, ich bin überzeugt, daß so hier schlimmeres
verhindert werden kann ... und wir so unterstreichen können:
Nie wieder !

Sehr verehrte Mindy Weisel, nochmal danke für Ihr Kommen,
das, wie ich meine, **auch Zuneigung** ausdrückt.

Zur Erinnerung, für Sie diesen Katalog zur Internationalen
Arbeitsbegegnung zeitgenössischer Kunst in Dachau 1995.
Anlaß:
50 Jahre Befreiung des KZ,
50 Jahre Ende des Krieges,
50 Jahre ...

... den bitte gerne alle anwesenden unterzeichnen mögen.
(Katalog)

Bruno's letter of Apology — read at Dachau luncheon
Oct 2009

132

Dear Mindy Weisel,

Thank you for visiting us. Thank you for your interest in Dachau and for your interest in what artists living in Dachau are creating. We appreciate your statement: "I come without resentment."

I admire you, Mindy Weisel, for your strength and resolve. You have really moved me. What can I, what must I, when and to whom do I, resist evil. When we object to someone else's opinions and have differing opinions, we must know when to just listen and when to object – to fight against what we know is not right.

My responsibility towards our history tells me – be present, listen carefully, get involved. When a word or deed is directed against the person standing next to me, directed against my neighbor, how will I respond? It is my responsibility.

We must be a force for the good. And I hope, I want, I am convinced, that a tragic history will not repeat itself: Never again!

Dear Mindy Weisel, thank you again for coming. This is a true expression of your respect and affection.

As a remembrance, we would like to give you this catalog of the International Working Meetings of Contemporary Art in Dachau, 1995.

The occasion for this catalogue:

50 years after liberation of the concentrations camps

50 years after the war ended

50 years...

which all the artists here have signed.

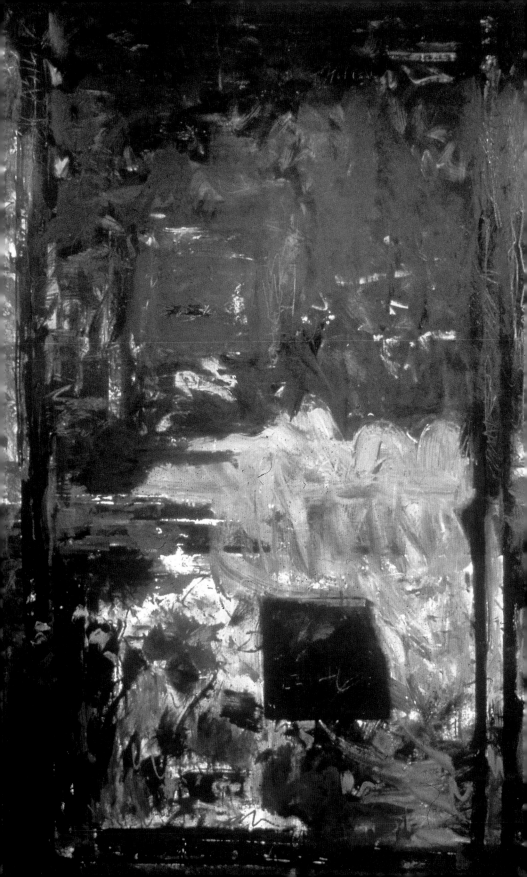

THE PALETTE CAME BACK TO HAUNT ME

Deep indigo blues, blacks, cobalt blues and light grays. These colors were on my painting palette for the year I worked on the *After the Holocaust* paintings. They were the only colors that I cared to work with. As I worked, I noticed that these deep blues, when mixed with some of the light gray, became luminescent. I would paint, layer upon layer, and, suddenly, a layer or section of light would break through. These colors, these compositions, these works expressed the feelings of loss I was experiencing while working on this series of paintings. The year was 1979.

While working on a painting in the *After the Holocaust* series, a large oil on canvas, *Lamentations*, the paints in blues, blacks and grays, would drip as if they were tears. Working on this painting was an emotional experience from start to finish. *Lamentations* is

"Lamentations," 1979, oil on canvas, 6' x 5'

a reference to the Yom Kippur service, in which there is a very moving line in the *Unetanneh Tokef* prayer: *B'shofer gadol yitokah v'kol demamah dakah yishama* – "The great shofar will be sounded and a still, thin sound will be heard." Perhaps, this is how I felt the world responded to the Holocaust: a great loud cry was sounded, yet only a still, thin sound was heard. I wrote this sentence, this phrase, at the bottom of this seven foot by six foot oil on canvas, and wept.

Almost twenty years after completing the *After the Holocaust* works, including this particular *Lamentations* painting, I had an unusual and somewhat shocking experience in regards to this work. My husband had come home from his law office, holding a magazine, and before even saying "hi" said, "I think one of your paintings is reproduced in this magazine... one of my partners left this magazine for me on my desk." We had dinner and later that evening, we opened the magazine, and were truly surprised. The image we were looking at, which did, indeed, look exactly like the *Lamentations*

"A Patch of Blue," Majdanek, 1996

painting, was not my painting at all. It was a photograph taken by an American photographer who travelled to Majdanek, photographing the interiors of the gas chambers, in 1996.

What looked like my painting was, actually, a photograph of the inside of the gas chambers, exposing the oxidation that took place over the past fifty years, since the liberation of Majdanek. The photograph was called "A Patch of Blue." The photograph captured what happened to the interior walls of the gas chambers… the walls that absorbed the last breath

A Patch of Blue

The inner wall of the gas chamber at Majdanek concentration camp in Poland glows in shades of eery blue in Arnold Kramer's photo for the United States Holocaust Memorial Museum. It appears in the winter 1995/96 issue of the Jewish literary journal Kerem, accompanied by an explanation by Chinese-American poet Harrison Tao: "[T]he grayish-bluish pellets of the Zyklon B gas left a blue residue: those beautiful blues were formed by the deposit of uncounted poison-soaked breaths. The darker the blue, the more that part of the wall had received repeated direct contact." In a poem/performance piece inspired by the photo, Tao writes: "With your one-color palette/you left the wings of birds, of the ink for words,/the blues of majesty, and honor, and hope…"

of each of the close to 100,000 people killed at Majdanek. The oxidation of the breath! The colors of the oxidation that took place over these past many years! How could these walls look exactly like the paintings I had done so many years ago? The photograph: deep indigo blues, blacks, cobalt blues and light grays. With an almost identical composition of rectangles as the *Lamentations* painting.

I had never visited Majdanek. I had not hoped to see the insides of the gas chambers. This was not in my consciousness. The colors of *Lamentations* and the photograph seemed to express the loss, the sadness and the tragedy of a horrific history. Yet, how is it, the painting done in 1979, which preceded the photograph by almost twenty years, reflected what became of the gas chambers? There remains the mystery between art and life, as well as the conscious and the unconscious mind. Not to mention the heart.

Viewing the devastation in Tohoku, at the Tsunami site, 2012

AFTER TOHOKU

On March 11, 2011, 231 miles northeast of Tokyo, a 9.1 earthquake hit Japan, which killed 20,000 people and left 2,500 missing.

I am not blessed with defences nor filters when it comes to absorbing tragedy. It goes straight through to my heart. Tragedy has often left me with no choice but to crawl into bed and stay under the covers until I feel I can breathe again. The reality of the event comes in at an unbearable pitch. Later on, more often than not, I head to the studio, I find a measure of solace, and then the need to "memorialize" has me mixing paints again and I am back working. The first painting I did, after this disaster, was called "When their world ripped open." I had original Japanese papers in the studio – I ripped them, burned their edges, collaged them, painted.

The Tsunami of 2011, however, was ever present in my mind. A year later, March, 2012, I flew to Japan, to do humanitarian work with the Tsunami survivors, both young and old. These people, thousands of them, that lost their homes, families and businesses, were now housed in temporary shelters, being given aid, while trying to piece their shattered lives together, piece by piece.

I went to Japan to do art therapy with the survivors. I arrived in Tokyo a few days earlier than the rest of the team. I would be joined by a dance therapist; a translator; an American/Israeli women who would be assisting Yotam Politzer, IsraAid Japan Country Director, a non-governmental, non-political humanitarian organization, set up by a friend of mine, Meira Aboulafia, years earlier, when it was first called "Israel for Countries in Crisis." I had told Meira I had to do SOMETHING to help out in Japan and she suggested my doing art therapy with the survivors of the Tsunami.

In my first taxi ride, from the airport to Tokyo, I noticed a large book of photographs on a chain behind the taxi driver's seat – clearly, for passengers to look at. It was a book of photographs on the Tsunami. The entire country, a year later, was still grieving. This was my first introduction to the devastation I later witnessed. Every taxi in Japan had that book in the back seat for passengers to view.

When I first arrived in Tokyo, ahead of the others, I was staying at the Tokyo Hilton. I noticed the cherry blossom trees had no blossoms on it and I was wondering if the Tsunami destroyed the

trees near the Tsunami site. As soon as I settled in at the hotel, I then arranged to be taken to the site of the Tsunami. One of the Hilton managers agreed to drive me to the Tohoku area where the indescribable devastation of the Tsunami hit. Now, a year after the Tsunami had leveled the earth I witnessed not only the massive destruction the Tsunami caused, but also the organizational skills of the Japanese government. I witnessed the organization of devastation. There were tons, literally tons, and miles of debris – clothes; household objects; books; shoes; miles and miles of debris all organized by material: miles of wood scraps; miles of plastics; miles of clothes. I had never seen anything like it. What once were streets, businesses, schools, homes, stores, was now a vista of destruction – a city, seaport and residential area completely washed away. It was hard to believe what I was seeing. It was particularly eerie, as there was not a soul in sight. Just the Hilton manager and I. I cannot really adequately describe the scene. Cars were piled up like crushed toys, hundreds of cars one on top of each other. Lives lost. Homes lost. Work lost. The loss was beyond language. And I did not see even one cherry blossom tree.

Once the others arrived in Tokyo, we met in the Hilton lobby and were taken to the town of Sendai. The SMILE hotel, in Sendai, was where we all stayed for almost three weeks. Our rooms at the SMILE were the size of a small closet. I loved it. We would then meet every morning at 6:00 a.m., head to the central train station, riding, half-asleep, to the temporary shelters in the Watari area, where the Tsunami had hit hard.

We started our work day meeting the survivors at the enormous Recreation Center, a temporary set up, near the temporary shelters. Our time there was meant to be a time of shared music and art experiences which would allow the survivors some relief and a place in which to express their pent-up grief. At the center, long tables and chairs, rows of them, were neatly arranged and set up for activity. I was asked to set up the art supplies and was strongly advised (an understatement) to line up the materials: oil pastels, paper, and other supplies in perfect order. Japan is the most organized, immaculate, polite country I had ever been to. In fact, before leaving for Japan, I was given a guide on the proper etiquette. Even "accepting" a business card from someone was a ritual. When a card is presented to you, you do not just simply say thank you and put it in your pocket. I learned it was essential to stop, accept the card, look at the card, look at the person and then put it away. It was the same even accepting change in a shop.

The first day together, at the Recreational Center, I met young children who had lost their homes, and people of all ages, gathered, seeking comfort and company, during this time of their shared grief. I asked them, through the translator, what is it they missed most. Most of them said they miss their families or their garden or their pets. Most of them were comfortable with the art materials and I suggested they draw a picture of what they missed. The children made drawings of home and family. And pets. Many of the older people drew their homes and gardens. They also drew

An 80-year-old woman's drawing with her house being washed away in chunks.

At Watari with the survivors of the Tsunami

pictures of their homes being washed away in chunks, and gardens dark and floating. Every single picture expressed emotion. I noticed that after about four or five drawings, even the children, having worked quietly and calmly, would start to weep while working on about the fifth picture. This is where the therapy comes in. Draw and draw and draw until your grief surfaces and you can grieve openly.

The first day, at the Recreational Center, people were shy. By the third day, I would be greeted by smiling eyes, many hugs, and a sense of excitement. One young boy was very sad that all his books had been washed away, and he wanted to learn how to make his own books, which we helped him do. We were engaged not only in art, music and games, but we also helped the survivors pick through clothes from the tables set up with the volumes of humanitarian aid that came in from around the world. There were clothes for all ages and for all sizes, to sort through, as well as objects: everything from sunglasses to wallets, to small mugs and pots.

I fell in love with a chubby, in her 40s, "mother earth" of the group. She would show up daily with some home-baked breads and cakes, made in her little stove, in her temporary shelter. Interesting how often, in situations such as this, one can find the leader and/or the "loving mother." Observing the people supporting each other through this tragedy was very moving. I held back tears almost daily, yet, when they played music it was hard not to cry. Their strength, resolve, kindness would move me to tears. After a week

at the recreation center, a translator was not even needed. I spoke no Japanese, they spoke no English, yet, our hearts spoke to each other. The word most often heard was "Sakura", which is their word for cherry blossoms and it also means hope. Their art was often filled with images of cherry blossom trees. They were a hopeful people.

At least one day of the week we left the temporary shelter area and ventured out into schools that had not been destroyed. Schools

"Tohoku VI," paint and collage on handmade Japanese paper, 50 x 25 in
Collection of the artist

where the trauma, the roar of the Tsunami, was severe. We would show up with gifts, candies, songs and stories. The children looked forward to our visits. Their faces spoke volumes. Meetings were also set up with professionals: teachers, therapists and social workers – in which I explained the methods of art therapy they could then implement in their work with the survivors.

146

Handmade Japanese papers I brought back from Tokyo

Fulfilled and spent at the same time, our work done, we headed back to Tokyo, where I had a chance to spend a few days alone. While in Tokyo, I spent most of my time looking for handmade Japanese paper. The Japanese are masters at this craft. I went to a paper-making factory and saw thousands of sheets of the most beautiful papers I had ever seen. By the time I was packing for the airport, I had collected an enormous amount of paper, which required I wrap them up into what looked like a rolled-up carpet.

Once home, our entire living room had these stunningly beautiful Japanese papers spread out on the floor. It was a gorgeous sight. I started work on the "After Tohoku" series as soon as I returned. The very first work I did was a collage called "Sakura." I had so many stories… I found I wanted to make collages out of these gorgeous sheets of handmade paper. Perhaps, it was my desire to take torn and broken pieces and put them back together again.

By the way, when I was leaving Tokyo, I noticed cherry blossom trees along the streets, and I knew that beauty and hope had survived the Tsunami. Nature has a way of surviving.

"Tohoku III," painting on handmade Japanese paper, 40 x 60 in

Collection of Carolyn Weisel Miller

WE ALL HAVE OUR MEMORIES

When we arrived in New York, in 1949, the HIAS (Hebrew Immigrant Aid Society) was instrumental in our establishing new lives. The HIAS was also the agency that placed me in an international nursery school for survivors' children in the lower East Side. I loved this school. All of us children, from all over Europe, were learning English together. We were all starting our life in America together. I most loved having lunch with my new friends and hearing all the different languages spoken. I remember trying to tell a new friend, (I was still speaking only Yiddish then) that my favorite lunch was creamed spinach on a baked potato. It still is. Sans the cream.

The second year at the school, the annual Chanukah/Christmas party was the best ever. Just thinking about it makes me truly happy. I was five years old and my parents and I took the subway from their bakery in Bensonhurst down to the school. I was filled with great excitement just being together with my hard-working parents, heading to a party.

The party started out with songs sung in many languages. At the conclusion of the ceremonial celebrations for the holidays, the teachers announced that a special activity would be held before we could head home. We were told to all go into the larger classroom near the one we were in, as a surprise awaited us. Walking into that classroom and seeing the floor-to-ceiling wall of toys, dolls, games, looked like every child's fantasy. A huge peg board on one wall held hooks on which every imaginable toy was hanging. It felt like hundreds of games were on that wall. Hundreds! My classroom teacher set a timer, and when the timer went off we had three minutes to run to the wall, and as many games, dolls, toys you could gather, until the time was up, were yours to keep. And if, at the end, you collected the most toys, you were then given an extra one, for being the winner.

I ran the fastest to the wall. I held onto toys, dolls, games, one falling on top of the other, and I WON! I got the most toys. I was the winner! I was ecstatic. I will never forget the subway ride home. We needed an extra seat on the subway for all the bags we

were now going home with. I went home a happy child. I won. I was the fastest. I can still see my parents, as if it was yesterday, probably exhausted by then, schlepping bags of toys through the subway turnstiles. I was going home with toys! What, at that time in our lives, could my parents have known about American toys?

I had a reminder of this experience when I was in Japan, doing art therapy with the Tsunami survivors, in 2012. A similar event was set up by IsraAid, for the children at the temporary shelters. The entire length of the Recreation Center, from one end of the room to the other, had a large colorful cloth spread out on the floor. On the cloth, games, toys, scarves, costume jewelry and dolls were lined up in perfect order. As the game started, when the timer went off, and the children started running towards the toys, I started to cry so deeply, I had to leave the room. I could not stop crying. Yotam Politzer, the IsraAid leader of this humanitarian mission, followed me out, checking to see if I was OK. I apologized profusely for leaving the activity, and I told him the memory that this scene had triggered simply overwhelmed me. Yotam, in an attempt at comforting me, said, "Everyone helping out here, with these Tsunami survivors, has at least one crying experience like this. We all have our memories. This was yours."

Studio in Jerusalem

THE IMPORTANCE OF PLACE

One thinks of artists as wanderers, explorers, leaving home to find their voice. Though, it seems, that even when they do leave home, they take their home with them. James Joyce, for example, left Dublin, yet every book he wrote took place in Dublin, his childhood home.

I found that I felt and responded differently in my work depending on where I was. In New York I felt a certain bohemianism that I most certainly did not feel growing up in Los Angeles. In Washington, D.C., where I painted most of my life, I had to work hard at staying close to my soul – it can be a very *soul-less* place.

With the question of *"how important is place?"* ever present in my mind, I learned that in my life, both professionally and personally, where I am IS significant.

Soon after moving to Israel, making *Aliya*, in 2012, my daughter, Ariane, who was already living in Jerusalem, found a studio that was *out of a movie*. In the luxurious neighborhood, Baka, in Jerusalem, she discovered an Ottoman era, two-story building that was uninhabitable. The top part of the building was empty. The bottom part of the building, about 2,500 square feet, high ceilings, Ottoman-style metal windows, a bathroom and small kitchen with the paint peeling and the tile floors broken. I loved it. I could paint. Make a mess – it was fine.

Walking to the studio from our apartment nearby, as I passed the tree-lined streets fragrant with purple flowers, white jasmine buds and violet bougainvillea, I was not sure I was really alive. What if I wasn't and this was actually heaven. I write this in all seriousness. I would call my daughter and check… It was an incredibly beautiful out-of-body experience, living in exotic, beautiful Jerusalem. Just entering this old, large, light-filled space in which to paint, felt meaningful.

Each painting began, as it always had, with writing directly on the work. Unlike earlier works, which were filled with memory and the past, I felt that my work was responding to the present. Inspired by Israeli poetry, Israeli music and the Jerusalem light that changed by the hour, I often felt as if I was visited by the muse. Jerusalem the muse.

In spite of Jerusalem's historical, political and religious conflicts, I feel myself to be in a secure place; a most beautiful and inspiring

country; a place in which I feel emotionally safe. Safe to explore a world of feeling that requires continued emotional honesty and intensity. I did need to leave home to feel most fulfilled. I am home. And in the right place.

I had visited Israel first in 1968. I had three uncles living there, who chose Israel after their liberation from Germany. I fell in love with Israel. The beauty of the landscape, the air, the European feel of it all. I loved that it was a small country and possible, in one day, to get from the ocean to the mountains and to the desert. Like Georgia O'Keefe and her New Mexico, perhaps Jerusalem has been my true artistic home all along. My heart most certainly felt that way on every single visit.

After my husband's entire family moved from Los Angeles, California, to Jerusalem, in 1983, visiting Jerusalem became an annual trip. We took our three daughters to visit their grandparents, aunts and uncles. I was always sad to leave. Then, in 1993, I was awarded a painting Fellowship at a highly respected and beautiful Artists Residency in Jerusalem, facing the Old City, called Mishkenot Sh'ananim. For a month I lived in the golden light one hears so much about. As I was packing up my art supplies to leave, I thought, "One day, Israel will be home."

As Emily Dickinson famously wrote: *The heart wants what it wants – or it does not care.*

Mindy Weisel

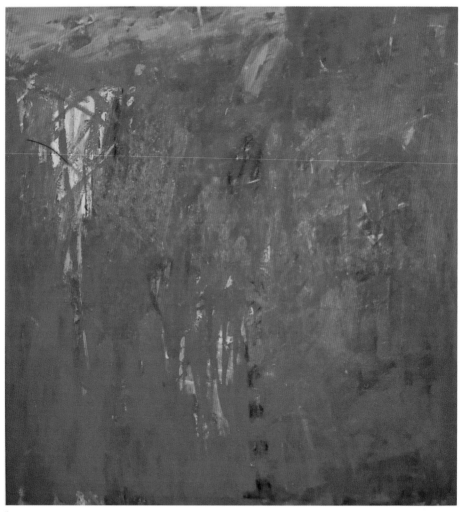

"Unconditional," 2015, oil on canvas, 150 x 140 cm Collection of the artist

MEDITATIONS ON LOVE

Love is never stagnant; it is most fiercely independent; necessary; vital; universal; beyond language; willful; an essential aspect of our lives. Love has a life of its own. It is its own planet and I want to be a permanent resident.

The search for the essence of love has served as a catalyst for artists, writers, thinkers and scientists for centuries. Love, however, as Rabbi Abraham Joshua Heschel suggests, is ineffable. It cannot be pinned down; we cannot live without it. It informs our very existence. It is boundless. The best summation is Emily Dickinson's timeless quote, "All I know about love, is that love is all there is."

To love fully, to be open to life, to give gratitude, has been my lifelong exploration as a painter.

Journals I wrote since the age of 13

Journals 1960 – 2010

JOURNAL ENTRIES
(SELECTIONS FROM 1988–2002)

F Street Studio, 29 November 1988

I didn't want to come up here today. I knew fatigue was starting. I read *Rilke's Letters to Merline* – "there is no such thing as family happiness and making your art." I wonder lately. How did I ever make a painting while raising young children? I am so tired by my life right now. I feel heavy. So much just wanting to eat and sleep. I don't think I'm a "real" artist: real artists don't watch the clock. Do real artists get tired?

F Street Studio, 17 May 1989

I haven't written here since the winter. I pulled myself together "yet again" worked steadily December to March on the Echoes series. I took Carolyn to a health retreat in Florida in March. I'm trying to stay off sugar, exercise regularly and keep my life "even" so I can make my work.

Jessica's Bat Mitzvah is this weekend: Carolyn graduates High School; Ariane completing 1st grade and reading (I love that I can leave her notes and she can read them!) Enjoying the relationship with my new Gallery: Jones Troyer – and I feel very "up" about the Echoes work. First body of work I've done where I've not felt crazy working. Just coming up here – "finding it" as I went along. The exhibition (my 1st one-person show in 3 years) opens in two weeks. Curious to the response.

Read some good books this winter:
Anita Brookner's *The Latecomers*
Steinbeck's journal while doing *Grapes of Wrath Working Days*
Edna O'Brien *High Road*
Margaret Atwood *The Cats Edge*

Started Body–Movement at Synergy Dance Place love what it does to my well-being. Clean living. They have live musicians playing drums.

Today life feels "in order." I made it up to my studio! It was starting to feel like a "scary thing" again. So just cleaned up and made some calls; having lunch with Harry R. cleaned up and am prepared to start it again. I look forward to the search. Are you kidding! I dread it!

F Street Studio – 5 June 1989
"Echoes" is up at Jones Troyer. I love these works and the press, sales, response has been strong. I haven't worked now in a month –

details and interruptions. Happy for the excuses of not working – happy the children needed me, the gallery needed things of me – but am starting to feel that emptiness that sadness that happens knowing I have to start in again – wanting to and not wanting to at the same time.

I just got a call from one of my Haifa students – Amit – she wants to study art in the U.S. I know the expense and I wish I could say, "Don't start" – but for her, I think it's too late. She's serious.

I read John Steinbeck's journal *Working Days* – it sounds like anyone who tries to pull something out of himself sounds the same. Insecure. Why ever the hurry to finish a work when I just have to start in again. A lifetime of difficult beginnings. So here goes.

F Street Studio – June 12, 1989

I feel like I've been on a roller-coaster emotionally. The openings (for *Echoes*) at Jones Troyer were wonderful. Lively – sold well – good press – they were happy with the response to the work as am I. But now to start in again doing work – a lifetime of beginnings that I'm in for. Why? What else to do with my life? I need to get back to a working routine for the summer. I find I don't ask "why" about anything when I'm working.

F Street Studio – 11 January 1990

I love being up here. Dealt with much since last entry here: Carolyn went off for a "year in Israel" terrible separation anxiety on both our parts – she returned after 3 months – depressed. She's now

straightening out and is a great joy. I've been busy with life: kids, Shel, friends, house, my intense *emotional condition* – at times feels helpless. I try to come up here 3–4 days a week for a 3-hour time span. Sometimes there is energy to paint, sometimes just to read (Robert Henri *Art Spirit*, etc.), sometimes to connect with a friend on the phone and sometimes like now (waiting for the plumber) I write. Too little time for everything. And sometimes when the time is there, the energy isn't. Can't always "get it together." The music. The light. It feels good up here today. But I'm freezing – why at $900 a month do I not have heat?!

Silver Spring Studio: "A Harmony of Sorts" – 8:00am/ July 23, 1991

For 3 months now I am convinced I will never paint again. No depth of feeling towards *anything* now. I busy myself with morning walks; watering plants; lunches with the children; friends; entertaining; shopping and as time moves on I get more and more depressed and feeling empty. Then "it" happens – *nothing* can keep me from this room and I no longer look for the excuses of being kept away from the studio. It's like I have been "filling up" while away from working – totally unaware and once again it catches me by surprise and life needs expression.

The urgency to get feelings out in paint are all powerful. I realize as I work on the "A Harmony of Sorts" series that what I long for is the intense energy of getting what I need to say across quickly, honestly and completely while the feeling is real. Feels real.

Completed "A Harmony of Sorts," March 1992

Last July 1991 I started "A Harmony of Sorts" – I just delivered all the work to the framers and it's all titled, signed, measured and ready for the exhibit opening May 7th. I hope it's well-received and well-reviewed.

I think this is my strongest body of work to date. Funny, I always feel like I'm not working *enough*. A lot of work was in response to family matters this year: Ariane's hospital stay ("Heartbeat" and "Monitoring Love"); Jessica's and my trip to Switzerland ("After Switzerland") Shelly ("When We're Not Speaking"); Carolyn ("Cold Monday").

I'm starting a new series called "Committing to Memory" (a line from Joseph Brodsky's *Less Than One*); and I will reread essays from *Less Than One* ("In A Room and A Half" my favorite) and read his poetry – I'm so inspired by the language.

I *knew* I'd meet him! Went to hear Brodsky read at the DC JCC and to a party at Aviva Kempner's afterward – introduced myself – he signed my copy of *Less Than One* – we talked and he said I could call him and told him I'd like to talk to him, as I'm painting to his writing. I wasn't going to call, then I did, thinking what do I have to lose. Truth is I'm always excited by the adventure of new people, smart minds, which always feeds or fuels the painting – creates the energy that allows me to create. Life gets flat without the stimulation of books, films, art, people, I look for quiet. I look for excitement. It's a constant struggle to balance it all.

Train From N.Y. to D.C. – 2 January 1992

Never wanted to keep a sketchbook. No patience for that. But definitely need a place to put thoughts, notes to myself, and drawings which I can call "agitations."

In 5 days I will be 45. I am starting this "sketchbook" or this "notebook" to mark my departure from emotional pain. I need to let go of heartache.

I have started sessions with a new woman psychiatrist – in an attempt at learning to live in peace with myself. I have had it with the great, great empty sadness of the past! Of what my parents went through. Of the great cost to myself, emotionally, of trying to live and to feel and to be for them. I'm sorry about what they endured. Their loss is immeasurable. But *my* life in *reality* is good. I would like to live in peace with my life. And to believe I can still be creative and *alive* without all the tumult and excessive intensity and energy I put into everything.

I tell Dr. S I've never been an artist who can work more than 2 ½ hours – 3 times a week – over the course of a year the work adds up. She says, "So what's the problem? *That* is the kind of artist *you* are."

I wish I were living in Europe with a huge loft or New York with a huge loft or anywhere with a huge loft. But children. And reality. And I just have to create my own excitement in my studio.

Suburban life and all. Suburban life is not for me.

I don't like my suburban life. I dislike malls. I hate not being able to walk anywhere I need to walk. I need to move. I need fresh coffee where I can sit and see people. I need to walk to a bookstore. I hate the suburbs. So what is to be? I'm trapped.

———————

In New York today: Phillip Taaf's paintings at Gagosian – Elegant. Not exhilaratingly exciting, but worth looking at.

– Stewart Davis exhibit at Met. So much work. Didn't like anything till his own "style" evolved early 50s.

– Agnes Martin at PACE.

– Most exciting work at PACE upstairs: John Chamberlain's monotypes. Tempted to buy one. I'm delusional that I could afford one.

– Wonderful lunch at E.A.T.S.

– Bought small box of fresh sweet raspberries (in January!) in what used to be Fraser Morris for $3.00 and ate them walking down Madison Avenue.

– Of course my frozen yogurt at Amer Health Bar on W. 57th.

– Bought some John Berger books at Books & Co.

– Some art supplies at MOMA to use in this book.

– Agitations – !!

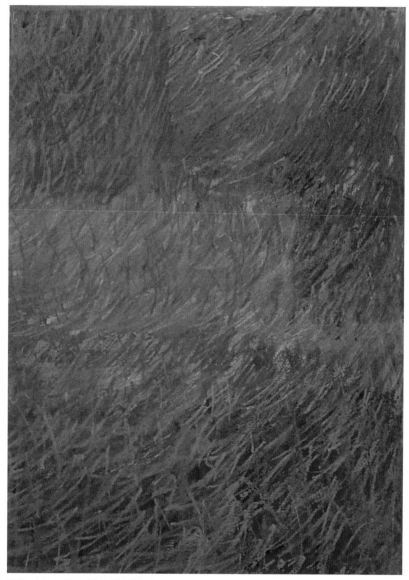

"Friday's Rain (Gray Friday)," 1992, oil and pastel on paper, 40 x 28 in

March 8, 1992

I've paid too high a price emotionally trying to be "perfect" for my parents – terrible emotional burden – driveness = illness. It's time to live *my* life.

I'm back with Dr. Mendel and on Prozac.

Last Session with Dr. – 10 March 1992

– Important to keep boundaries clear. I cannot get swallowed up by my family life.

– Not to take lightly the need to be away from D.C. – "go to N.Y. and travel."

– Learn to rest and "give yourself a break."

– I tell Dr. S. my mother still tells me she can't be happy unless I'm happy – what a burden – Dr. S. says I have spent my entire adulthood looking for a *self.*

Bal Harbour, Florida – 29 June 2002

Right before I got here, this past Wednesday, I finished "The Rose Print Project" for the young girl in Israel, Chen Kainen, 26, who lost both her mother and her 15-month-old daughter in Israel, suicide bombing – she and her 28-year-old husband survived. I raised $5000 after expenses for her – I did this work with what I just realized is my "heartbreak energy" – either I will sit and my heart will just *break* or I'll move, move, move, move, move, move and I'll survive the heartbreak.

Dr. W. said I designed an entire personality, an entire energy, around my profound anxiety. An anxiety that ultimately wears me out – how much running and rushing and doing I need to do just to cope with it. Exhausting. I'd say it's more like not having skin. Everything gets absorbed.

So here I am in Miami – in the white, high-ceilinged, light-filled apartment, we are renting. The first night here I tossed and turned with chills that felt like I was, literally and physically, "shaking off" life in Washington. Shaking off the intensity, the adrenalin, the demands, the rush, I live with there. First 3 days here Jessica and Ariane, who is here to help with our newborn – I just laugh and laugh – I kiss Asher, our first grandchild. He's a delicious baby, and I hug him and hold him and melt as he smiles at me. I am in a state of wonder and awe and joy and bliss and aware that "it does not get better than this" as we have a warm loving lunch on Shabbat here, in the apartment with Jess, Daniel, Asher and Ariane. I am more at peace here – I can read here because I am not distracted. I can sleep here because I am not anxious about the next day.

Today is the fifth day I'm here – with my anxiety level dropping daily. I slept from 11:30 pm – 8:45 am last night and felt very very quiet all day. Jess tells me I sound "tired," Ariane asks me "what's wrong?" I think my entire chemistry changes.

I miss Shelly who will be arriving later than I had hoped.

Mystical experience Thursday morning – 6:30 am: jump out of bed, go onto the balcony as I watch the sun come up, one dark cloud formation forms in front of the sun in the EXACT shape of the rose in "the rose print" – the sun then creeps up behind the one big "rose cloud" with light, literally, outlining the cloud shape, as if it is backlighting – took my breath away.

I awake here each morning expressing the deepest, deepest gratitude for life itself. For the blessings in my life.

But today I am quiet all day. I am quiet in the crowd of things and people at Sports Authority; I am quiet at the clamor at Best Buy; I am quiet at Whole Foods. Strange to feel emptied of the anxiety that fuels me at home in DC. Is this how most people who are not "anxiety driven" feel? I'm not sure I am comfortable with this kind of calm and quiet – but really hope to hold onto it as long as I can. I tell Ariane this morning, as if complaining, I guess, "I sleep so much here and read a lot here." And Ariane says, "I hope you will let yourself enjoy it."

I am not sure why I have this overwhelming need to express so much to my daughters about my interior life – perhaps it's because I really knew so little of my mother's. The need to be known is probably my greatest motivator. When I am quiet like this, I am mysterious even to myself.

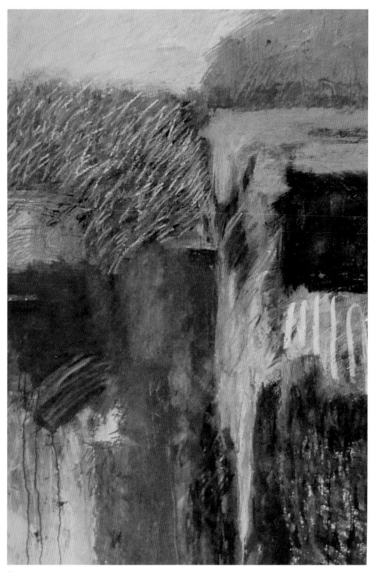

"Of Country Fields and Torn Skies," 1992, watercolor, oil, pastel, 60 x 40 in
Collection of Margy Seides

Touching Quiet Journal Entries

Tuesday, July 7, 1991 / 7:50 a.m.
I slept really well last night – felt safe and "finally here." Got up at 6:45 a.m. – bathed quietly in my bathroom (I've not yet met the person next door who shares this bathroom) and went down to breakfast: fresh biscuits, eggs, cereal. At the table: Ann, a fiber artist; Simone, a writer, and Janice, a writer. Interesting and warm and friendly. It is a gorgeous, clear, sunny day. I just walked into my studio into the most gorgeous morning light I have ever seen. Unbelievable that the day and night will be mine for a month. I'm all settled and have everything I need in my simple little bedroom and my spacious studio. Interesting, how happy I am with so little – not burdened by things that need my care and attention. I am thrilled by what I don't have. No phone. No TV. No car. Not much furniture. No objects. Just light and peace and quiet and fields and fields of summer.

Wednesday, July 8, 1991 / Studio, 2:15 p.m.
I couldn't really start to paint till around 11:15 – and I felt very anxious about getting this *Touching Quiet* out – tried different papers and different paints – frustrated, I finally took a break and then did a watercolor on rice paper – I loved the softness, the way the sheer paper absorbed the paint and left the feeling of quiet – I sat on the floor for three hours and did six washes on rice paper,

then collaged them onto stronger watercolor paper – I feel happily spent – I just finished. The piece really reflects the soft heat of summer and the quiet air around me. Will read for a while now, then go do my two-mile walk.

Thursday, July 9, 1991 / 7:45 a.m.

I'm going to work on a painting called *Torn Skies*. On my walk after dinner last night, I noticed that the mountains seemed to touch the sky and their outline looked torn, the way I tear paper to do a collage. Also, the title is a good metaphor for my life in general. I start each morning here with Richard Stoltzman's music – a gentle clarinet tape called *Inner Voices* – and I study paintings by Manet. He is clearly one of my favorite painters. His brilliant brushwork, color, composition, and use of black are just plain exciting. One of my favorites is *Lady with Fans – Portrait of Nixa de Callias*. His use of black is as a rich color and not a void. It is elegant and mysterious.

10:30 a.m.

The painting *Torn Skies* became *Of Country Fields and Torn Skies*. I really had to push through myself to paint it "freely," without thinking. Just feeling. I tell myself to not think as I work. It will not help me to think. Just feel what I need to feel and use the materials to express that. Finished it at 4 p.m. Incredible this staying here all day – running nowhere. Time to reflect – look – rest – work.

Monday, July 13

From 2:30–4:30 worked on a painting I first called *Anxiety in Green* but now I'm changing the title. (I had a *terrible* anxiety attack in my studio this afternoon – felt trapped, alone; another three and a half weeks of this quiet – can I take it? Will I be able to keep working?) Terrible panic attack. Painted through it. Calling the painting *A Storm of Solitude* instead and will continue to work on it tomorrow. Hopefully feeling less anxious.

Tuesday, July 14 / 11:30 a.m.

Had a good morning working – finished *A Storm of Solitude*. Feel better. The flash of light coming out of the darkness is exactly how I felt once I got through the anxiety of being with so much silence. Don't feel as lonely today. I was invited to go to the lake this afternoon at 4 p.m. It's so hot here, I know that should feel good, yet I feel guilty for leaving the studio. But everyone talks about the lake and how cool and beautiful it is in this intense heat. How can I not see the lake while I'm here? I remind myself I have time to do all I need and want to do, and I should allow myself this pleasure.

Wednesday, July 15 / 12 noon

Working on a piece called *The Lake*. Worked all morning on *The Lake* and finished it. I am happy with it. It is magic born out of a real struggle with my materials or a real using of all my materials – watercolor, oil, pastels, chalks, watercolor pastels, etc. The piece feels like the cool, cool, lake of the other day, filled with many, many shades of blues and greens.

Thursday, July 24 / Studio, 2:30 p.m.

I read Tess Gallagher's poems for one hour in absolute silence. And I cried when I finished reading, and while still crying, I put on Bach to do a black-and-white work on paper called *A Day with No Hurry*. I'm going for a walk. I'm drained. I didn't have any energy left for color today, only black and white.

Friday, July 30 / 8:00 a.m. – last morning here

This has been a very "positively reinforcing" time. I have learned that I need to continue to work on being more in control of my generally exhausting emotional life – by just resting more and not taking on so much. I definitely do too much at home. No wonder I get totally depleted. I always want to do so much – but one day, you do wake up and say, "I am only one person."

I would like to give thanks, here and now, for this month in which I found the strength to do all this work that clearly was in me, longing to get out; for having the time, the energy, the desire, the inspiration and the freedom in which to do it. A month from heaven.

Take Hold

If there is nothing
before you, take hold
of it. You may be fortunate
or not. Place it deep
in your pocket regardless.
It is a possession
as no other.

When you are to leave and
have made all your
arrangements; when you
are ordered to declare all
your possessions, reach in
to the dark pocket.

This is no symbol
traveler, no parable.
Nothing
is as whole as the space
in the air
you pass through.
And it is yours. If
you will take hold of it.

– Merrill Leffler

I love working with glass. It's not only, probably, my subconscious antidote to Kristellnacht, I love that the layers of work are visible. Layers of paint inform the painting, whereas glass becomes light itself.

Glass Installation at Tel Aviv Eretz Israel Museum, 2013–2019

"Blankets"

Notes/memories in Studio 1988

BLANKETS

During a session with Dr. Mendel, I was overcome by a memory of my father's severe asthmatic attacks I witnessed as a child. At eight years old, I was already worried sick that he would die. Doctor M. asked me what else I remember of that time, in New York. My answer surprised me: Blankets. That is what I remembered. Blankets. My father would have violent shivers during his attacks, and my mother would pile their Hungarian down quilted blankets on him, to still the shivers.

Driving to the studio after that session, I started visualizing *blankets*. As soon as I got there, I took the first sheet of paper on my work table – a large heavy sheet of drawing paper – and started writing: Blankets.

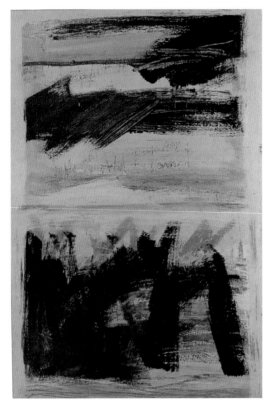

"In the Face of Solitude," 1992, acrylic on paper, 22 x 16 in

Blankets. As a young girl, witnessing my mother running out of the house in flames, after our Brooklyn fire, she was thrown to the ground and rolled in heavy Italian blankets belonging to our neighbor Maria. When I was able to visit my mother at the hospital, after the fire, they would not allow me in, but said my mother would come to her hospital window and I can blow her a kiss from the street below. My mother was wrapped in a blanket of white gauze. She looked like an angel.

In photos of concentration camp victims, we see people as skeletons wrapped in gray wool blankets. There have been many beautiful

coats and jackets that I never could purchase if they reminded me of those gray blankets.

As I got older, blankets started to represent happier moments. Married at eighteen, my mother gifted us with a quilted European blanket. It was stunning in its satin cover softness.

One of my favorite gifts, at the birth of my first daughter, Carolyn, was a red and white gingham blanket. There were soft white blankets, as well, after the births of my daughters Jessica and the youngest, Ariane. Pinks, yellows, whites. My children's blankets.

At thirty, I took a colorful striped blanket that my husband and I had acquired during a trip to Mexico to my first art studio. It became my art blanket. Then, as our family grew, the patterned picnic blankets and faded worn blankets for the beach, became very much a part of our family life.

That day, alone in the studio, I wrote and wrote until, finally, visualizing all these blankets in my life, I pictured covering Ariane, as a baby, with the creamy white blanket she loved, and I started to weep. The memory of feeling safe with my children tucked in for the night. That was safety.

ACKNOWLEDGEMENTS

I am very grateful to the following people whose love, support, wisdom and patience have allowed this book to take all the time it needed:

Jen Klor, first and foremost, the exceptional graphic designer whose heart joined mine on every page.

Elizabeth Sheinkman, who became the loving custodian and guardian of this book.

Martina Kohl, whose generosity and belief in my work is beyond language.

Julia Koppitz, editor, advisor and friend at whitefox publishing –

thank you for everything during this challenging year of Zooming. I enjoyed your smile across the ocean!

There are not enough words, in any language, that could thank Malka Margolies for her time, energy and love – and to Thea Wieseltier, who brought us together!

Ellen Barry, your positive energy and generosity is incomparable.

My family: Carolyn, Dave, Jessica, Daniel, Ariane, Ofer and your dear children, to whom I dedicate this book, you continue to inspire me, for which I remain grateful.

With all loving wishes to the Courtney, Deutsch, Margalit, Miller and Weisel families.

I have been blessed with genuine friends, you all know what you mean to me.

For Roz Barak, whose belief in beauty taught me, at a very young age, that life is art.

To Shel.

After

In Memory and in Gratitude to James Johnson

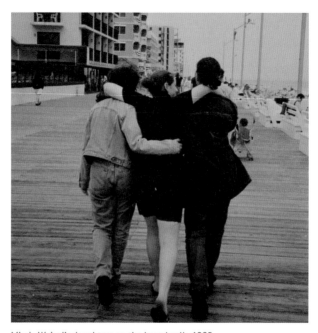

Mindy Weisel's daughters on the boardwalk, 1995

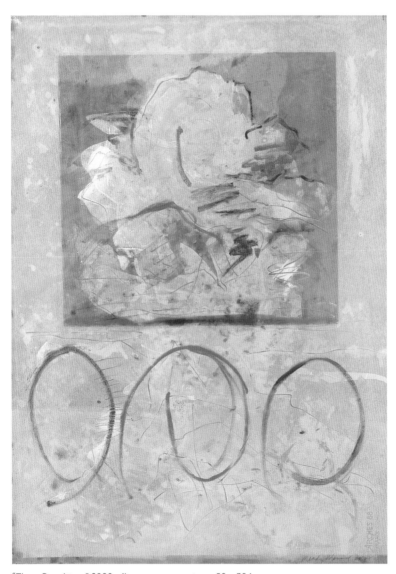

"Three Daughters," 2008, oil on paper, monotype, 50 x 30 in

Collection of Anne and Ronald Abramson

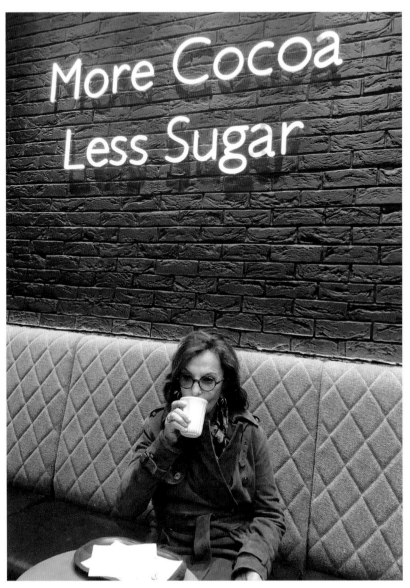

At Oxford: Bergen-Belsen to Oxford. Thankfully, life is good.

AFTERWORD

Mindy Weisel has written a remarkable book that is as beautiful in its content as the art she has produced over her productive career, parts of which are highlighted in *After: The Obligation of Beauty*.

Our lives intersected in numerous ways. I have been the beneficiary of her artistic work, as my late, beloved wife Fran and I acquired several of her artworks under the State Department's Arts in Embassies Program, to our official residence in Brussels, Belgium, when I was United States Ambassador to the European Union, for all of our visitors from the U.S. and throughout Europe to see and appreciate. When we returned back to Washington, where I was Under Secretary of Commerce, Under Secretary of State and

Deputy Secretary of the Treasury, we were overwhelmed by her generosity in gifting several of her works to us.

Mindy Weisel's book is unique and important for several reasons. First, as she states in her book, she has been "living a life in search of beauty" since she was among the first children born in the Bergen-Belsen Displaced Persons camp (formerly the concentration camp) after World War II to two parents who survived the horrors of Auschwitz, her father also one of the few survivors of the infamous January 1945 Death March from Auschwitz. This book is not another history book by a child of Holocaust survivors about the tragedies of the Holocaust faced by their parents. She consciously did not write a book about the Holocaust itself or what she learned from her parents' experiences. Rather, *After* is about how she found in art the ability to "speak about the survival of beauty," the "will to live with beauty," by someone who fully absorbed the unbearable traumas her parents endured in the Shoah, who sought beauty and meaning "in the face of a tragic history." As she eloquently describes, art to Mindy was the antidote to human pain and suffering, an obligation to seek beauty and joy of living, to survive and thrive the "black hole" into which she was born. She describes how she "took my sadness and made paintings." As someone who has devoted a substantial part of my career in government and outside government seeking justice for Holocaust survivors and imparting the lessons of the Holocaust to today's world, Mindy's book has a special resonance.

Second, in her chapter narratives, accompanied by her artwork relevant to those periods of her life, she covers a life filled with accomplishment and meaning interwoven by being the child of Holocaust survivors. She describes a childhood in terms only a child of Holocaust survivors could evoke: "Who had a childhood? We had parents who survived hell and we, their children, felt responsible for their every happiness." Her first awareness as a young child of being moved by a work of art came not from a museum or art book, but from a pencil drawing by her father shortly after the War, of a sun rising in the bleakness of Bergen-Belsen. This was the inspiration to "fall in love with the power of art." But she also absorbed a lifelong lesson from her father's admonition not to be consumed with hatred for what was done to him, her mother, and millions of other Jewish and non-Jewish victims of the Nazis: "Mindeleh, if you live a life, things happen. Enjoy what you can."

As an abstract expressionist, she "was not concerned with painting as an accurate description of anything but what life feels like. To express what is beyond language." And that is what I have found in her paintings.

She describes in moving terms being "obsessed" with her father's Auschwitz number A3146 tattooed on his arm when he was nineteen years old, writing it on all of her canvasses for a year. Another chapter is devoted to explaining an artwork as imagining the "death smell my mother endured in the cattle cars on the

way to Auschwitz," from Hungary, one of eleven siblings whose entire family was taken by Nazis during a Passover Seder meal to Auschwitz. Her mother, Lili and her father Amram, met after the war at the Bergen-Belsen DP camp, fell in love, and were among the first weddings held there in January 1946. An enchanting chapter, entitled "Lili, Let's Dance," was taken from a greeting by her mother's oncologist, and which led to a series of paintings in honor of her mother.

Mindy felt life come in a circle when she accompanied Holocaust survivor, famed writer Elie Wiesel, a cousin, to the first meeting of the United States Holocaust Memorial Museum Council meeting and then for the groundbreaking for the museum several years later. Again, this has a special meaning for me, because it was my April 1978 memorandum, as White House Domestic Policy Adviser, along with White House Counsel Robert Lipshutz, to President Jimmy Carter that led him to create the Presidential Commission on the Holocaust chaired by Eli Wiesel, and which recommended establishment of the Holocaust Museum.

A particularly arresting chapter is entitled, "Dachau is Closed on Mondays," recounting her experience in visiting the town of Dachau and the nearby concentration camp as a Cultural Emissary from the State Department's Cultural Affairs office. Her description of the welcome she received from the mayor of Dachau; the lunch with four contemporary German artists in a dining room with six memorial candles in a silver candelabra as

a visual commemoration of the six million Jews killed by Nazi Germany, one of whom, the son of a Nazi official, wept in remorse for what his father and that generation had done to the Jews; and her talk with over a hundred teenage children at the Dachau Educational Center where she spoke about her art, and one asked in excellent English, "How does our generation make sure this never happens again?" Mindy made clear that there should be no bitterness of those who came after their parents or grandparents committed unspeakable crimes.

Last, her speech in Oxford and the entire book, is not only about art, it is a book with lessons about how we should live our lives. Her "belief in moving forward with love," despite the tragedies in life; to refuse to believe in hate; that "the only antidote to hate is in expressing love for mankind;" that "only love and a passionate move towards action for the good can enrich our world." Mindy Weisel in *After* makes clear that life is always filled with good days and bad days, with joys and sadness. But as she concludes, our job is to make the most of the "half NOT broken – the half that still beats with the excitement of possibility – that makes life worth living."

– Ambassador Stuart Eizenstat